CRAFT AND ART

LITHOGRAPHY

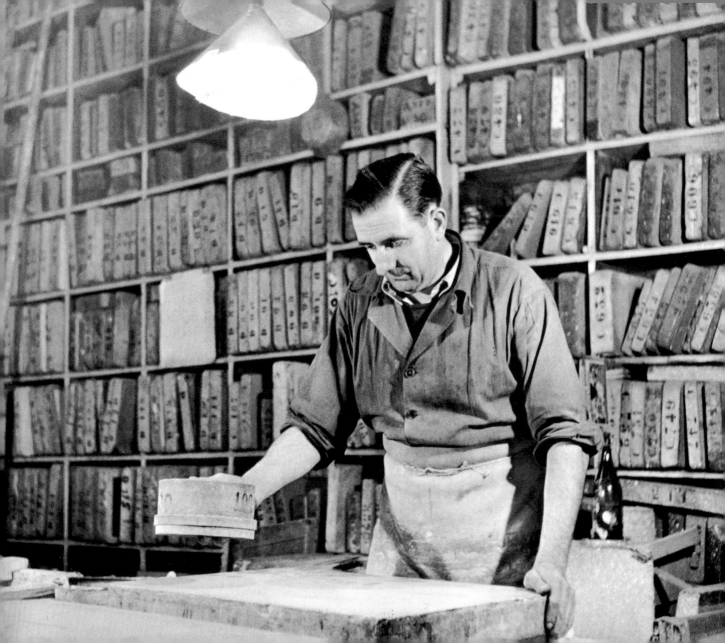

CRAFT AND ART

Renée Loche

LITHOGRAPHY

VAN NOSTRAND REINHOLD COMPANY

New York · Cincinnati · Toronto · London · Melbourne

Library of Congress Catalog Card Number: 73-8466
ISBN 0-442-29991-5

Printed in Switzerland.

Published in 1974 by Van Nostrand Reinhold Company Inc., 450 West 33rd Street, New York N.Y. 10001 and Van Nostrand Reinhold Company Ltd., 25–28 Buckingham Gate, London SW1E 6LQ.

Van Nostrand Reinhold Company Regional Offices:
New York, Cincinnati, Chicago, Millbrae, Dallas.
Van Nostrand Reinhold Company International Offices:
London, Toronto, Melbourne.

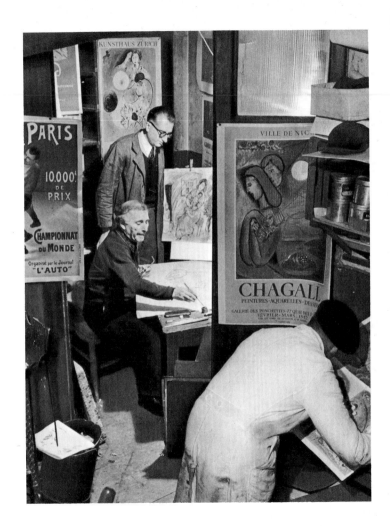

CONTENTS

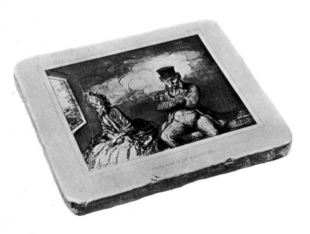

INK ON A STONE

A stone, greasy matter, water and ink . . . – a list which sums up briefly what is needed to make a lithograph, that is to say to transpose a drawing made on a stone to a sheet of paper. This volume is not a technical manual for specialists. It is intended rather to provide art-lovers, visitors to musuems and exhibitions and collectors with a full description of the technique and history of lithography. We have tried to explain – leaving an important part to the illustrations – the different stages in the creation of an original lithograph, from preparing the stone to the final printing. The book also shows that the art of printmaking is an encounter between artist and craftsman which calls for intimate collaboration on their part. Without this collaboration no worth-while work could exist. An index containing definitions of the main technical terms, selected bibliographic references and a synopsis will help the reader find easily what interests him and, if he likes, deepen his knowledge.

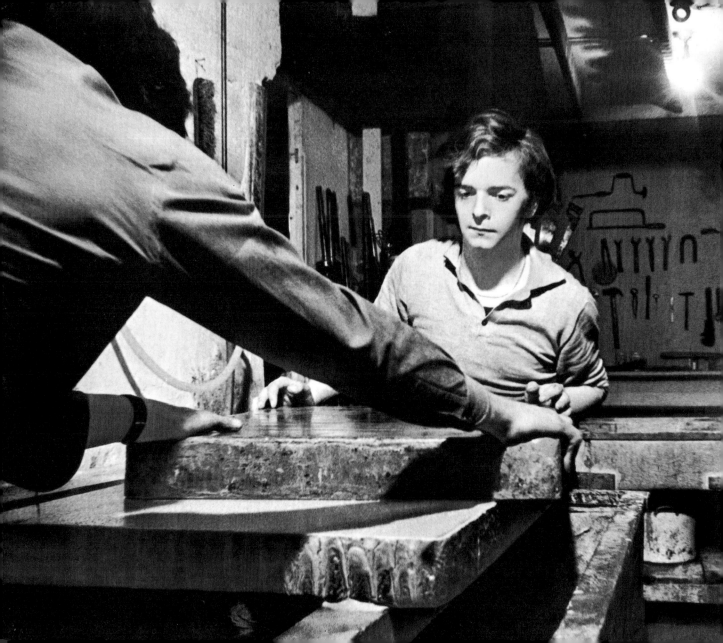

1 THE STONE

Origin

The stones used for lithography come mostly from the Solenhofen quarries near Munich. Once quarried they are cut into rectangular slabs from 3 to 4 inches thick. The dimensions of the slabs are chosen in relation to the nature of the work to be performed.

Made from very fine limestone containing 94 to 98% of carbonate of lime, a substance which breaks down easily under the action of fatty acids, these stones have a natural *grain* which catches greasy particles; they also soak up water like a sponge. They vary in quality: some absorb water better than others depending on their degree of porousness; some are harder than others, which affects the way their surface will take *polishing* and *graining*. In colour, they range from yellow to grey blue depending on the quality; the grey stone, slightly brownish, is the most sought after; it is harder and more closely textured and because of the fineness of its grain is more uniformly penetrated by greasy matter. It is used for all fine work, in particular for crayon lithographs

The stone is placed on the graining table

and *transfers*. The yellow stone is less prized; it is too soft and too coarse to take such fine graining, which causes some difficulties during printing.

The lithographer must make sure that the stone has no flaws, for veins, cracks or cristals interfere with or spoil printing.

A stone can be used hundreds of times; if it has been so thinned by successive grainings that it can no longer stand passing through the press, it can be *lined,* that is to say cemented to another stone.

Once a stone has been chosen for lithographic work, it goes through the first stage of its *preparation*. If it is new, it must be squared until its surface is absolutely level.

The levegator or "Jigger"

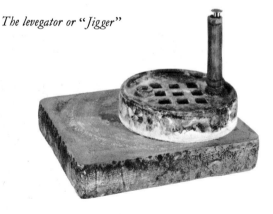

If it has already been used, it must be rubbed free of the old drawing. In both cases the process is the same.

It should be noted, however, that since most lithography workshops use almost exclusively old stones, it is essential always to efface the drawing in order to re-sensitize the stone.

The surface is ground deeply until there is no longer any trace of the grease that had penetrated it, so that not even the slightest part of the old drawing will reappear during printing. This can be done in two ways: either with a *levegator,* or by using a second stone.

The slab is first cleaned with a solvent – usually turpentine – to remove any remaining printing ink, after which it is washed thoroughly. It is then moved to a *graining table*. Its whole surface is sprinkled with water and strewn with a strong abrasive, usually coarse-grained silicon carbide sand. If the levegator or "jigger" – a circular slab of cast iron with a vertical handle – is used, it is moved over the surface of the stone while being made to

Abrasive being applied to the stone

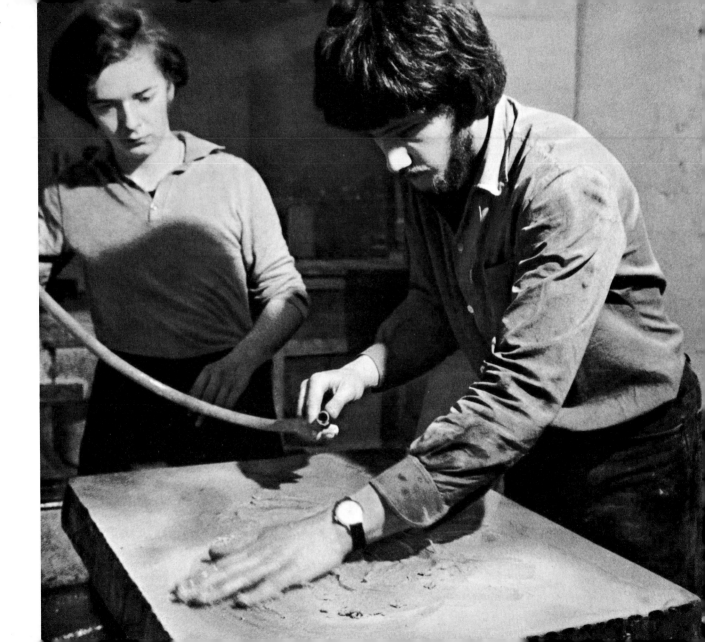

rotate rapidly by means of the handle. This instrument makes it possible to clean a stone more quickly and it is particularly useful for large surfaces.

Grinding with another stone is done as follows: once wetted and covered with abrasive, the lithograph stone is rubbed with a smaller stone held by two opposite edges, describing overlapping circles and figures of eight. This should be done gently, without applying pressure, over the whole sur-

Using the levegator

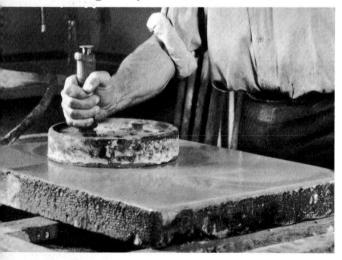

face, so as to keep it dead level. There must always be enough abrasive between the two stones to stop them from touching. The silicon carbide sand is used up when a thick slurry forms and causes the stones to stick together. The lithographer then carefully removes the upper stone without scratching the one underneath, which is now washed thoroughly.

This whole operation is repeated three or four times until the old drawing has disappeared. The stone is then wiped dry with a sponge and its surface is tested with a metal rule to see if it is uniformly flat.

Graining

A stone intended for a crayon lithograph or for a litho-ink wash drawing must be grained, in other words have a slightly roughened surface which will catch the grease in the crayon.

Graining, in fact, is the next step after the drawing has been removed. The same method is used but with a much finer abrasive. Sifted sand is sprinkled over the wet surface of the stone. During graining, progressively finer sands are used from grain-size 240 early on to grain-size 400 for

finishing off. As when effacing, one rubs the litho stone with a smaller stone of the same type, slowly going over the whole surface with a circular movement. The process is repeated each time with a finer sand and a thorough washing, until the desired grain has been obtained.

Polishing

If the stone is to be prepared for a pen drawing or a transfer, its grain must be fined down until the surface is perfectly smooth. To this end, a special *grinding-stone* containing a mixture of sealing wax and *alum solution* is rubbed over the whole surface in the same manner as above.

The corners of the stone should be filed smooth.

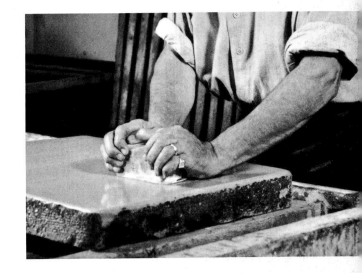

Polishing the stone with a grinding-stone

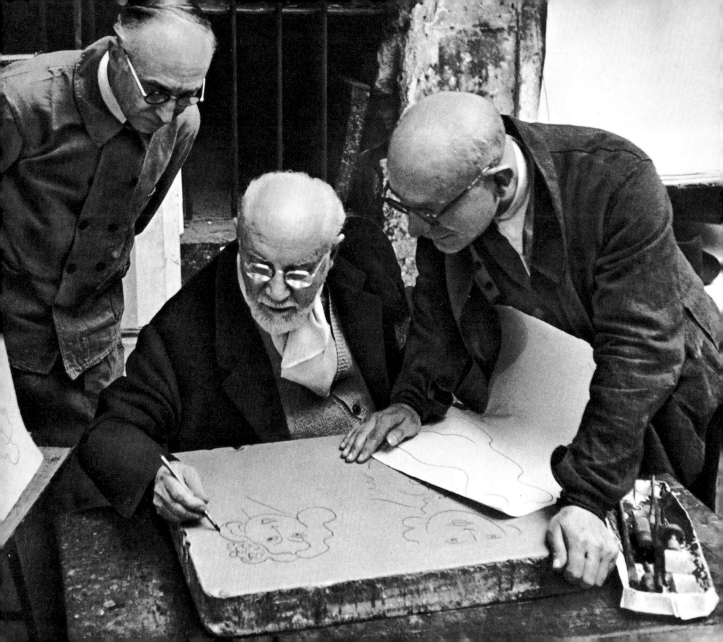

2 THE WORK OF THE ARTIST

The artist carrying out a lithograph proceeds exactly as a draughtsman or a painter would, for one of the particularities of this technique – unlike the relief work of woodcuts or the intaglio of metal engraving – is the use of a flat, more simple and directly accessible process, in which the stone, as Francis Ponge puts it in his excellent definition "is in no way hollowed out, only it has the singular quality of absorbing in depth what one lays on its surface, of committing it indefinitely to memory, and of being able to surrender it to the paper, under the press, with – shall we say – a sort of kiss."

Lithography gives the artist the possibility of using a great variety of techniques: he can express himself directly on the stone with complete freedom, using a crayon, a pen, a brush, a scraper, a needle or any other instrument of his choice. If he likes he can even keep on changing, erasing or adding to his composition. This is why so many painters, who were not engravers by trade, were soon tempted by lithography. The great innovators of modern art, such as Matisse, Braque, Picasso, Miró and Chagall

Henri Matisse drawing with crayon

(who, speaking of lithographic stone, went so far as to say "it was as if I were touching a talisman"), have given a new dimension and a marvellous brilliance to the discipline.

Lithography is based on a physical phenomenon: the repulsion of greasy particles by a wet surface. The artist therefore makes his drawing on the stone in greasy ink or crayon; the greasy matter these contain will form with the stone a chalky soap which attracts printing ink; the ink will adhere only to the greasy lines of the drawing, for the rest of the surface is wet.

While the making of lithographs presents no major or insurmountable technical difficulties – which helps explain why lithography is used in so many different fields, from fine art proper to advertising via posters – it is nonetheless governed by certain rules that are inherent to the very process.

Thus the artist has to invert his composition when drawing it on the stone if, on printing, he wants it to appear the way it was conceived. Also, certain precautions are essential; he must never touch the non-

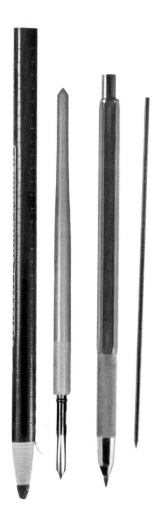

Litho crayon, pen, graphite holder, graphite

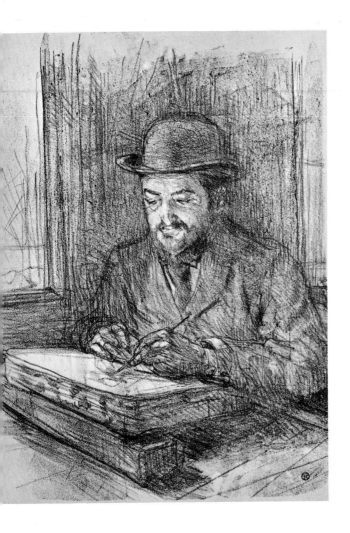

printing portions of the stone with his fingers, as grease secreted by the skin leaves indelible marks during printing. To avoid this a small sheet of cardboard or a stick of wood is placed under the hand as a bridge to protect the stone.

The design should not cover the entire surface of the stone. A margin about one inch wide should be left and protected by adhesive paper. This blank border will allow the printer to adjust and measure the pressure of his scraper during printing.

The artist, while working, will do well to remember that the slight greyness of the stone could mislead him since the non-printing or non-image surfaces will become white areas on the print and so will slightly modify the balance of tones.

The litho crayon drawing
The litho crayon was very popular towards the end of the XIXth century and was exploited with particular brillance by Daumier and Toulouse-Lautrec. Today it is still used by many artists either by itself or

Henri de Toulouse-Lautrec. Le bon graveur, Adolphe Albert, *1898. Black and white lithograph*

combined with brushwork. With it they can achieve a fine variety of *half-tones* with soft gradations from black to the lightest grey. The artist draws with a special crayon whose greasy matter sticks in the grain of the stone. Crayon lithographs are readily recognizable by their grain which resembles that of a lead pencil or black chalk.

Litho crayons are a mixture of wax, tallow, shellac, soap and lamp black. The greasy components form a chalky soap with the stone. The shellac, due to its binding quality, makes the litho crayon strong enough to stand sharpening and the pressure exerted by the hand. Finally, the coloured part – the lamp black – is there so that the artist can see what he is drawing.

There are different sorts of crayon: using them cleverly the artist achieves greater perfection in his drawing. Soft crayons are more often used for dark tones, the hard ones for fine and light tones. Rubbing crayon drawings with a cloth gives a smudged effect. Eugène Carrière often used this process.

The crayons are sharpened with a knife from the point downwards; the point

Sam Francis, Bright Jade, Gold Ghost, *1963. 5 colour lithograph*

Jasper Johns

should be long enough to be slightly elastic. One must note that delicate drawings should be made with a sharp point in order to produce a fine even print.

The first lithographers made their own crayons and inks. These days they are produced commercially, in many different qualities, by specialised firms. One sort of crayon is cylindrical, about the size of an ordinary pencil; it is wrapped in a spiral of paper and very convenient to use. The other sort, sometimes called American crayon, is a square stick about 2 inches long. Their hardness varies; it is graduated numerically by the makers, from 1 to 5 for the cylindrical crayon, from 0 to 5 for the square crayon. The hardest crayon contains a strong varnish of a copal base. The artist should choose those which best suit his intentions and correspond to the intensity of black he desires. For vigorous drawing no. 2 is most often used; no. 3 is more subtle. The greasiest crayon, which is used for shading, presents some difficulties: being very soft it tends to break on the stone or melt in the hand. Litho crayons can be fixed in a holder but are more often used like ordinary pencils.

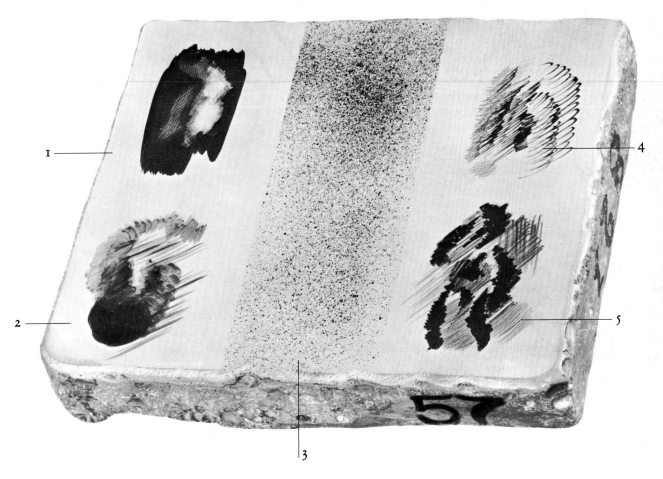

Examples of techniques: 1. *Manière noire* 2. *Wash drawing* 3. *Splatter* 4. *Pen* 5. *Crayon*

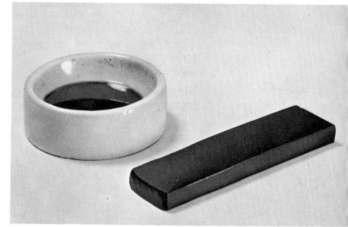

Crayons and litho-inks

To sketch in the outline of a drawing artists sometimes use an ordinary crayon – usually red chalk – which, since it contains no grease, does not print.

Once the composition is completed on the stone, whites can be hightened with a scraper or needle to obtain brighter high-lights. A brush dipped in litho-ink or more simply a crayon thinned in water can aslo be used for touching up.

Litho-inks

A special ink, called litho-ink, is needed for pen or brush lithography. Although it comes in various forms, this ink always contains the same basic ingredients : a greasy substance, shellac and lamp black. Its function is two-fold: first to form with the lime in the stone an insoluble soap capable of attracting printing ink, then to resist the acid which is applied to the stone during its preparation for printing.

Litho-ink is sold both in liquid and solid forms. In liquid form it is used for pen work or for covering whole surfaces with a brush. Soft ink, also called drawing ink, is usually diluted in turpentine. Solid ink comes in small rectangular slabs. To

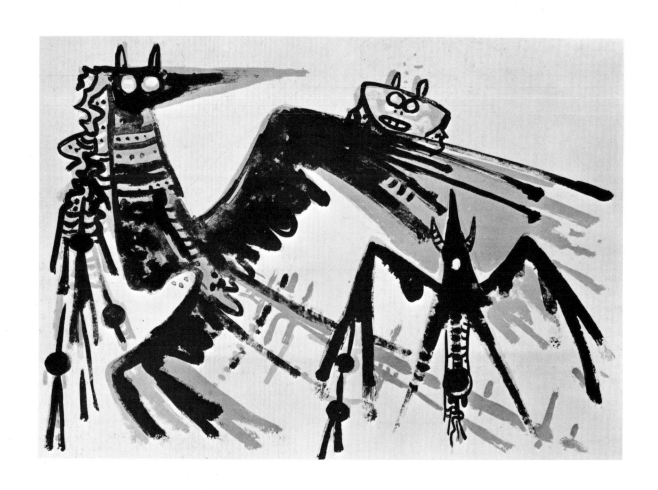

Wifredo Lam, Sans titre II, *1967. 4 colour lithograph*

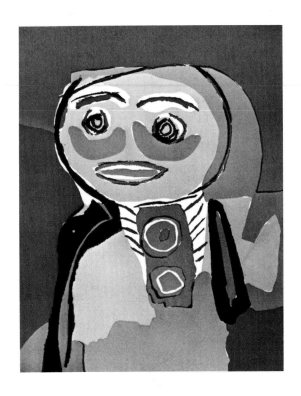

Karel Appel, Fille souriante, *1969. Colour lithograph*

dissolve it, one rubs the end of the slab round the inside of a porcelain cup; this causes a certain amount of ink to adhere to the porcelain. One then adds a few drops of distilled water and stirs with a finger until all the ink has dissolved. It is then ready for a wash drawing.

The litho pen drawing
Pen drawing was fashionable in the days of the French lithographer Nicholas-Toussaint Charlet, famous for his scenes of military life; more recently it seems to have been somewhat neglected in favour of crayon and wash drawing which offer greater freedom. However, many contemporary artists combine pen drawing with other techniques. The same pen is used for litho work as for drawing with Indian ink on paper. Fine, firm, rich lines can be obtained.

The litho wash drawing
For a successful wash drawing the stone must be carefully grained. Brushes of a size appropriate to the type of work are chosen. The tones of a wash drawing can range from darkest black to lightest grey

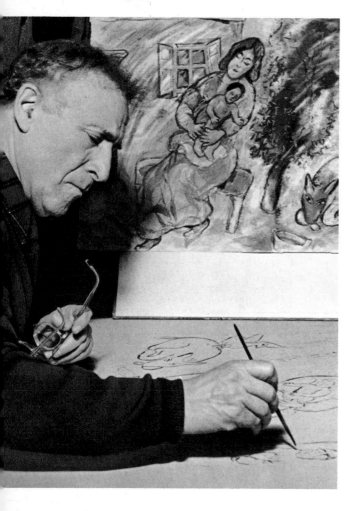

depending on the amount of water added to the ink. The artist proceeds in the same way as for a water-colour wash on paper. A very fine brush is needed to paint lines.

This is not an easy technique, since even the lightest tones must retain some of the greasy matter in the ink to come out in the print.

Turpentine or alcohol can also be used in wash drawing to dilute the ink. The quality of the print depends on the solvent chosen. While wash drawing allows the artist great freedom of execution it is full of problems for the printer. The very highest skill is called for to overcome the many difficulties that may arise during printing.

The splatter process
This technique was often used by Toulouse-Lautrec for the backgrounds of his posters.

Instead of applying litho-ink to the stone with a brush, the artist sprays it by rubbing an inky brush on a small metal sieve, so that the stone is splattered by countless small drops of ink whose density varies with the amount of ink used. Areas which are meant

Marc Chagall working with a brush

28

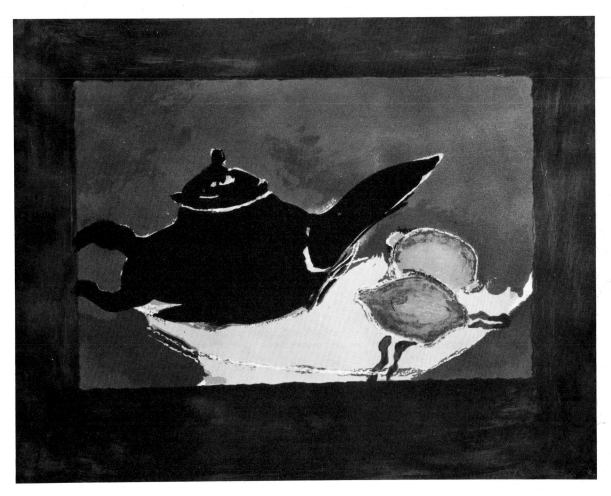

Georges Braque, Théière et citrons, *1949. 8 colour lithograph*

to remain white on printing are staged out by a protective coat of gum arabic applied with a brush.

"Manière noire"

In the method known as *manière noire* the whole surface of the stone is covered with greasy litho crayon or litho-ink. Some of the ground is then carefully scratched out with scraper and needle to produce a white negative drawing.

Scrapers are among the most useful tools.

Oil-stone, scrapers and dry points

They are essential for some kinds of work, for instance to draw in white on a black background, to subdue a tone or emphasize a detail. Their points vary in size and are sharpened on an oil-stone.

Two or more of the techniques described above: crayon, pen, wash, splatter and *manière noire*, can be used in combination.

An artist who has chosen lithography as a means of expression can be very daring indeed as long as he respects certain fundamental rules.

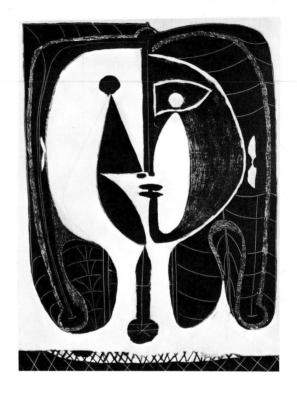

Pablo Picasso, Figure stylisée, *1948. Black and white lithograph (ink, crayon and scraper)*

3 PREPARING THE STONE

When the artist has finished drawing his composition on the stone the latter is prepared for printing. This is a very delicate operation as the quality of the lithograph depends on how carefully it is carried out; it is usually done by a lithographer. The solution used for the preparation of the stone is called an *etch*.

The etch consists of a mixture of gum arabic, water and nitric acid (2% concentration). This slightly syrupy solution is a very weak mordant. It serves to fix a film of insoluble gum on the stone as a protection against any fresh application of greasy matter, so that the areas destined to stay white will not accept printing ink. It also cuts the stone off from the action of the air and favours the retention of the water used throughout printing for dampening the stone.

Views differ as to the exact function of the acid in the etch. According to Engelmann, one of the first lithographers and the foremost authority on the technique, the acid is intended "to decompose the soap which is the basic ingredient of litho-ink

Lithography workshop

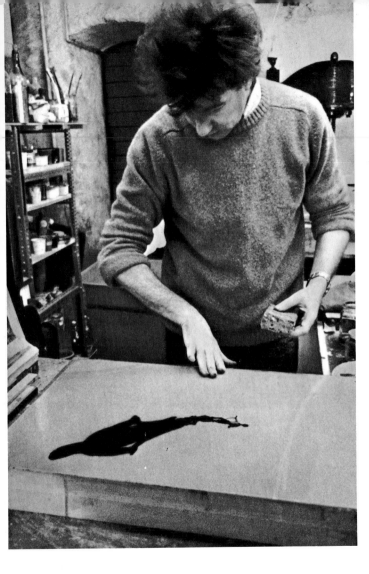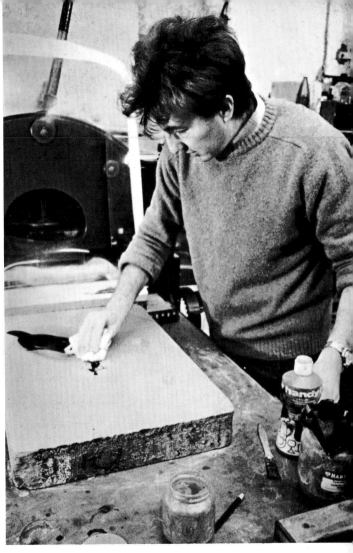

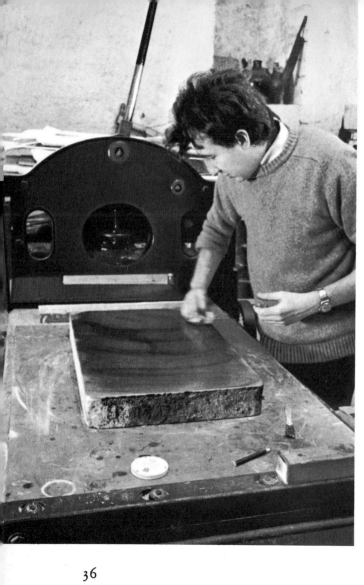
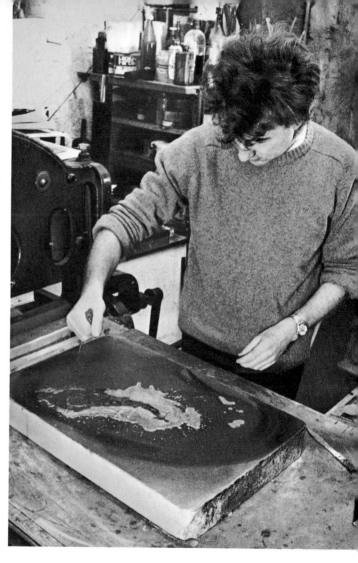

and litho crayons;" the fatty acids "thus liberated turn the marks on the stone into an insoluble chalky soap which attracts printing ink." Other lithographers think that the acid merely activates the gum arabic.

The preparation is always carried out the same way. It is done in two stages. Great precision is called for as too strong an etch will cause some fine details in the composition to disappear, while too weak a solution may result in the print being over-inked.

First stage
First the stone is dusted with talcum powder; this helps the etch to spread evenly over the whole surface leaving no gaps. The etch is applied to the stone with a wide flat brush, a flannel cloth, or a sponge. Some lithographers just use the palm of the hand, which makes it easier to concentrate on those parts of the drawing that need to be more strongly etched. This first stage preparation is then left to dry for a time that varies between 20 minutes and 24 hours.

The stone is dusted with talcum powder *p. 34*
The etch is spread over the whole surface of the stone

Gumming the stone after preparation *p. 35*
The drawing is dissolved with turpentine

The drawing is lightly blackened *p. 36*
The drawing reappears after a thorough washing

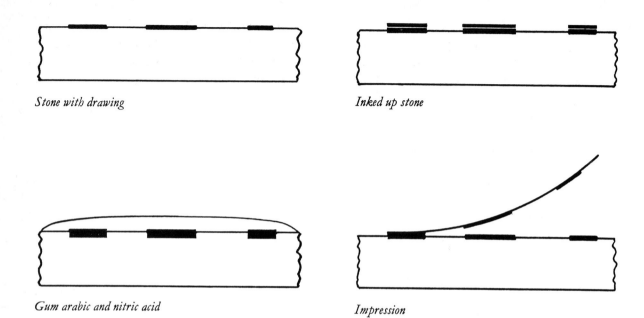

Stone with drawing

Inked up stone

Gum arabic and nitric acid

Impression

Stone after washing

Second stage

The etched stone is now placed on the movable bed of the press. The position of the scraper is checked and its pressure adjusted. Next the stone is thoroughly washed with a sponge. Then the lithographer applies a thin coat of pure gum arabic. The purpose of this coating is to fill the pores of the stone to protect it during washing with turpentine. The stone is fanned dry by agitating a small, stiff, revolving flag over its surface. After drying the stone is rubbed lightly with a cloth soaked in turpentine in order to remove the black of the crayon or ink used in drawing the composition, the lines of which thus become almost invisible; the drawing is said to be *washed out*. Although the coloured matter in the litho-ink has now disappeared the chalky soap that has penetrated the stone is still there and will accept the ink during printing. Next the stone is lightly blackened – usually with printing ink – and thoroughly washed to remove the gum arabic and any residue left from the turpentine cleaning. The drawing becomes visible again. It is now time for the first inking up; the stone is moistened, after which an inked roller is moved evenly over its surface until every detail of the drawing is sufficiently black. The work is ready for printing.

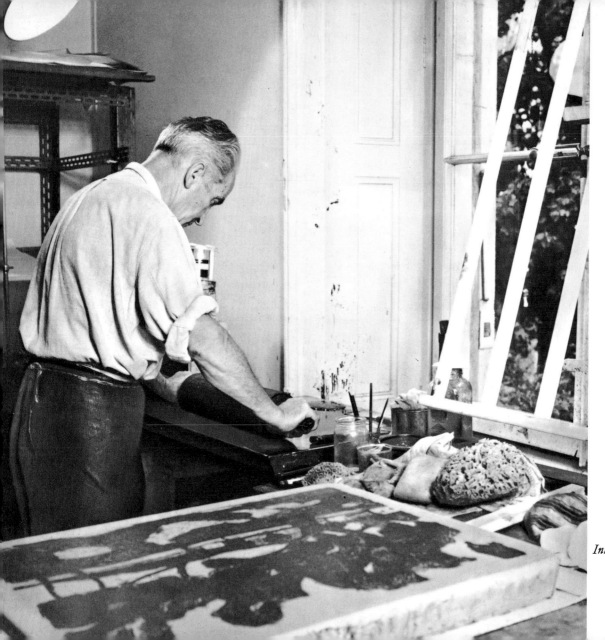

Inking up the roller

4 PRINTING

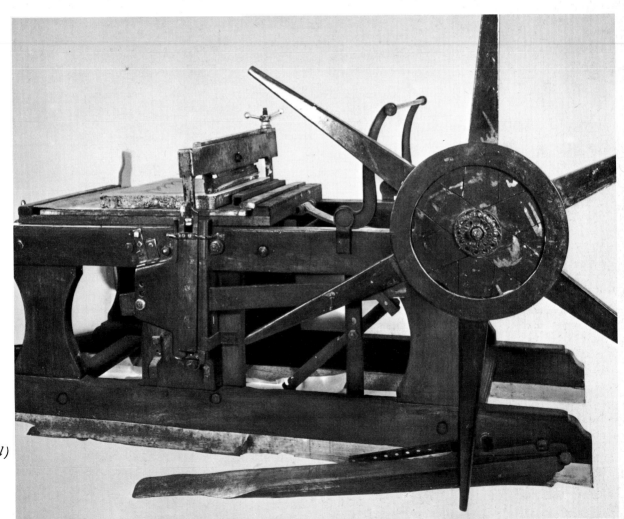

*A star press
(French model)*

Printing – one of the most important steps in the making of a lithograph – depends above all on the skill, intelligence and craftsmanship of the lithographer: for it is he who must judge how the print should look on paper in order to reflect exactly the artist's intentions and translate his message faithfully.

Art lithographs are always printed on a hand press as this is the only way to produce fine prints in which the intensity and variety of blacks and the subtleties of tonal value appearing on the stone are reproduced with total fidelity. There are two sorts of hand press: a French version which is made of wood, and a cast-iron German version. Both work on the same principle: pressure is applied to the stone through a scraper, the stone and the sheet of paper placed on it are shifted by a movable bed.

At first, Senefelder, the inventor of lithography, used either a letter-press printing machine or a copper-plate engraving press for his editions, then he constructed his own type of press which has remained in use, almost unchanged, to the present day.

The French press, known as a star press, is made up from the following elements: a *cylinder,* a *bed* on which the stone is placed, a *winch,* a *scraper-box* and a *scraper.* The printing paper is laid on the stone; it is backed with a few more sheets of ordinary paper and a sheet of compressed fibre-board to lend elasticity to the pressure. The bed is pulled by a strap which winds round the shaft of the winch. The latter consists of six arms of wood connected by cast iron ties. The lithographer turns the winch to run the stone and its paper covering under the scraper. On old presses a counter-weight pulled the bed back into its original position when pressure was released. The scraper-box is adjustable for two reasons: so that the scraper fit the stone exactly, and secondly to make it possible to raise the scraper when printing is done in order to gain access to the stone and proof. The fibre-board is placed on the stone just before printing, preferably greased with tallow to facilitate the slide of the scraper.

A complete set of scrapers is always supplied with both kinds of press. Their lengths vary according to the sizes of the compositions to be printed. These scrapers are made from very hard sorb-wood, and their edges are bevelled. Each one is cover-

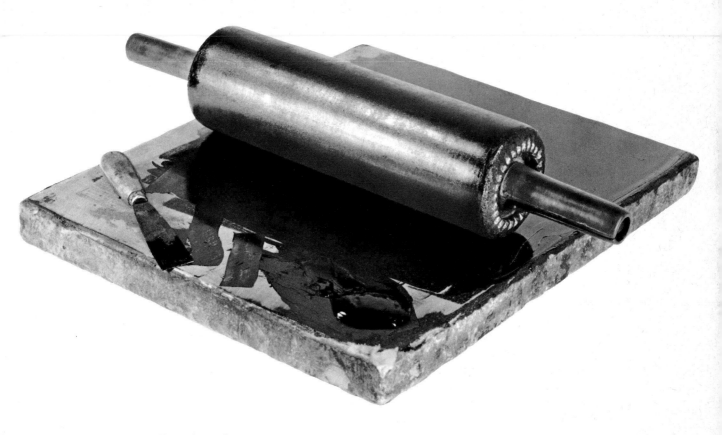

Inking stone with roller and spatula

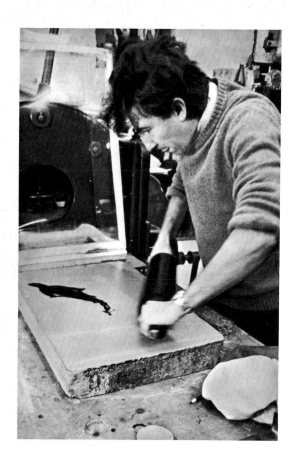

Inking up the stone

ed with a strip of leather to lend it some elasticity during printing. They too are greased with tallow in order to slide more easily when pressure is applied. When using a star press the printer adjusts the pressure by pushing with his foot on a long wooden pedal while he turns the winch with his hands to pull the bed holding the stone and paper under the scraper.

German presses are geared, that is to say that the bed is cranked under the scraper by means of a cog-wheel driven by a handle. The pressure of the scraper is regulated by a pressure screw. For printing the lithographer pulls down on a lever to apply pressure.

Handling a French press is more time-consuming, but the pressure produced by the foot pedal is both stronger and less brutal, and it can be increased or lessened by the lithographer at will.

Inking up

Once the stone has been prepared and placed on the bed of the press the lithographer starts inking up with a roller. Lithography workshops are always equipped with a selection of rollers to

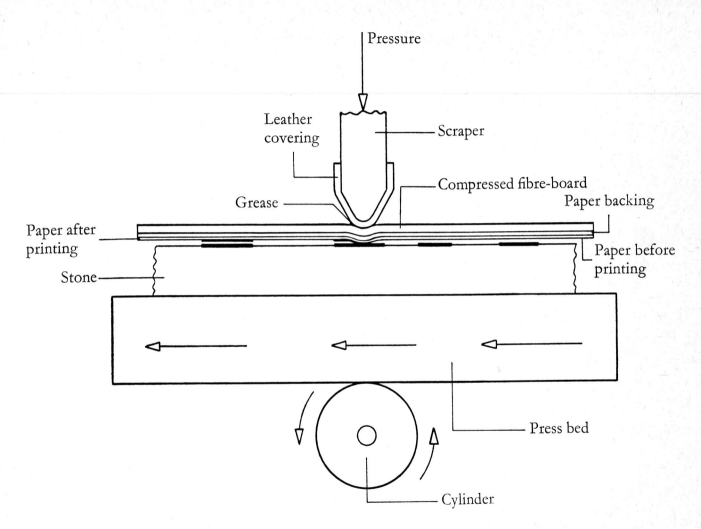

Pressure

Leather covering

Scraper

Compressed fibre-board

Paper backing

Grease

Paper after printing

Paper before printing

Stone

Press bed

Cylinder

45

suit the various sorts of art work. There are two types of roller: one for black and white printing – a wooden axle ending in two handles, covered by several layers of flannel topped by a tightly stretched leather skin; and one used exclusively for colour printing – a rubber roller. The length of the roller is chosen to suit the size of the stone and the dimensions of the composition. It should normally be slightly bigger than the drawing and smaller than the stone.

The lithographer spreads printing ink on a second stone, which he uses as an inking table; he does this with a spatula which he moves to and fro over the stone. The ink should be spread in an even layer over the whole surface of the inking stone so that the roller will not pick up more in one place than in another. The printer then runs his roller over the ink several times until the pores of the leather are thoroughly impregnated. The inks used for lithography are made up of a very dense, strongly coloured pigment which is quite insoluble in water. The ink should be stiff, firm and compact. The best proofs are produced with ink that is as stiff and black as possible.

After moistening the stone with a small sponge – for it is essential that the stone should remain damp throughout printing – the printer applies the ink by running the roller evenly and obliquely over the entire surface. To start with the stone receives the ink irregularly as the roller has not yet absorbed any humidity; but repeated rollings cause excess ink to be picked up from some areas and redistributed evenly in places where it lacks. If the lithographer handles the roller skilfully – slowly and with considerable pressure for intense blacks, or quickly and gently for light blacks – he can, if he likes, make use of the same roller to produce prints of varying blackness from a single composition.

After inking up the lithographer places his paper carefully on the stone, holding it by two opposite corners. He lines up one corner of the paper against a guide-mark made on the stone with non-greasy crayon, then drops the other corner onto a second mark. Very often the paper is dampened before printing. Once on the stone it is covered by a few sheets of ordinary paper and by the fibre-board backing greased with tallow, after which the bed is moved until one edge of the stone is directly underneath

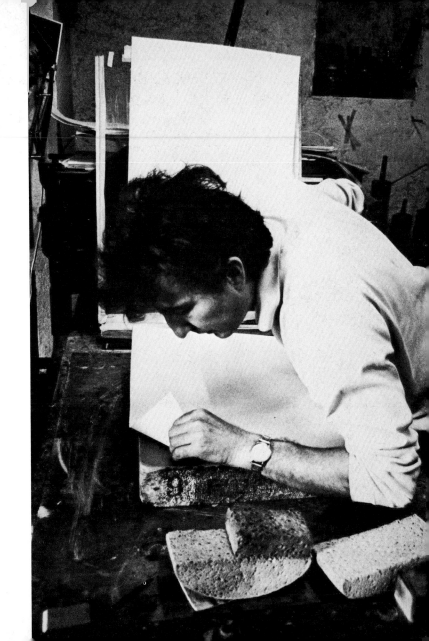

The paper is placed on the stone

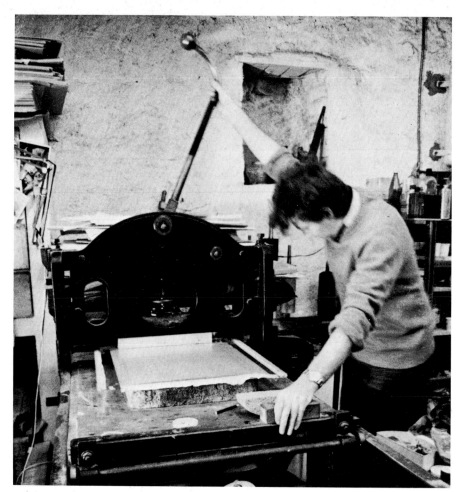

The bed is moved under the scraper

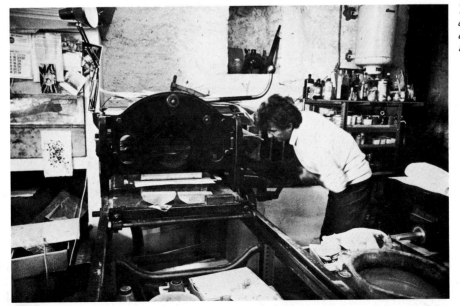

The printing
lever is pulled
down for
pressure to be
exerted

The stone
and paper
are run under
the scraper

49

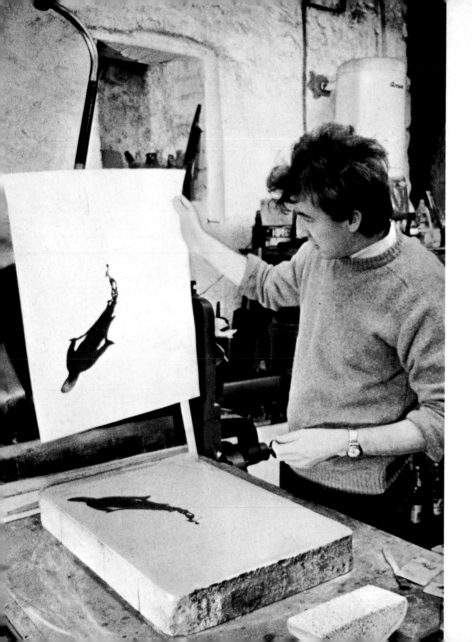

The proof is lifted off after printing

the scraper. Next, depending on which press is used, the lithographer either pulls down on the printing lever and cranks the bed under the scraper by turning a handle, or applies pressure to a foot pedal as he turns the winch. The bed must move smoothly without jerks or halts as these tend to show up as blurs on the print. He then lifts the scraper-box, brings the bed back to its original position, takes off the paper and fibre-board backing, and finally eases up the proof which pressure has caused to stick to the stone. Once removed the print is laid out flat to dry.

The paper
The quality of the paper on which lithographs are printed is of paramount importance. The beauty of its texture and of its grain, its suppleness and strength, are largely responsible for the success of a print.

Two sorts of paper are used for printing: hand-made paper or machine-made paper with a raffia or hemp base. Pure rag paper, containing rag-pulp in its fibrous composition, offers the most beautiful background for delicate work. This paper, made by hand according to an age-old method, is always marked with its name of origin: for example Arches, Johannot or Rives. As a further proof of authenticity it invariably carries a water-mark, a transparent mark or design impressed in the sheet of paper.

In the early days of lithography Japanese paper or India paper were used for fine proofs; being very thin, they were glued to a backing of good-quality white paper after printing.

Choosing a paper for printing calls for great care and discrimination as only a suitable quality will bring out the beauty and subtlety of the blacks and delicacy of the whites.

Composition on stone by Denise Voïta

A proof

5 THE ARTIST AND THE LITHOGRAPHER

The lithographic printer has always played an important role in lithography, taking an active part in the work of the artist. It should be remembered that XIXth century lithographs were signed both by the artist and the printer, whose name was preceded by the abbreviation *lith. de.* A great many lithographs of the romantic era would never have seen the light of day but for the workshops of Philibert de Lasteyrie, Engelmann, Delpech, Villain and Lemercier, to cite but a few names.

Today the creative artist and the printer very often work together to produce an original lithograph, to such an extent that their collaboration has frequently been compared to that between the artist and the weaver in tapestry. Braque, Chagall, Dufy, Matisse, Miró, Picasso and many other contemporary painters have been introduced to this process in the best-known workshops and have allowed themselves to be guided technically by the lithographers' sure craftmanship. Miró even stated in an interview "as for me, it has always been my hope to to work with others in a team like

Joan Miró signing a composition on the stone

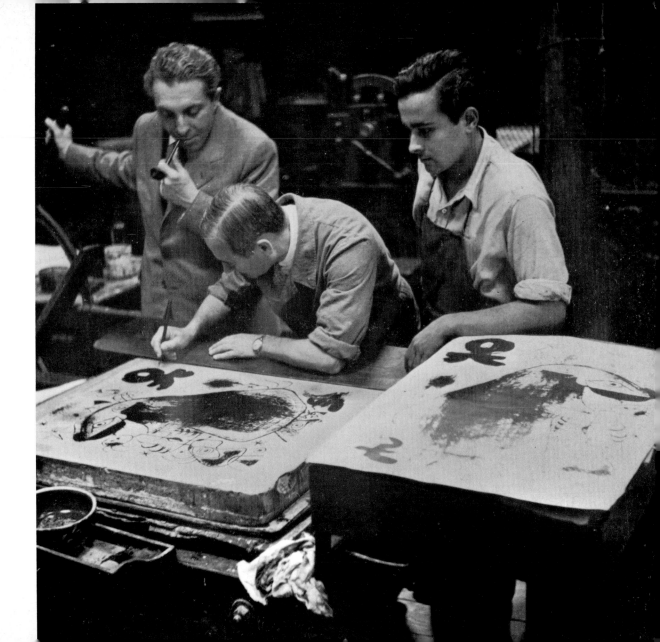

brothers. America has killed off its craftsmen. They must be saved in Europe . . . In fact in the last few years we have witnessed a sort of rebirth of self-expression through crafts like ceramics, lithography, wood-engraving and etching. All these art-forms, which are less costly than painting and often just as authentic in their plastic statements, will tend gradually to replace painting."

When the first trial proof has been printed, the artist examines it carefully, checking the quality of the inking up and making sure that it is not too heavy or blotched. This is the moment for retouching the stone and carrying out any extensive alterations that may be necessary.

If, for instance, the artist decides to remove some of the drawing, he will do so using a scraper. If, on the other hand, he wishes to add to his composition, he must first *neutralize* the stone, that is to say strip it of the hygroscopic film laid during the preparation so that its surface becomes receptive to grease again.

Scrapers or pumice-stone pencils are used to erase portions of the drawing. Once moistened, the area to be treated is rubbed with the abrasive. Regular wipings with a moist sponge will help check the action of the abrasive. When the scraping out is completed the stone must be etched again and recoated with gum arabic. Similarly, tones that are too dark can be lightened by rubbing gently with glass-paper.

Neutralization
The stone must be inked up and dusted with talcum powder to prevent the neutralization from attacking details of the drawing. The area that needs retouching is treated with a solution of acetic acid which is applied with a sponge for large surfaces, or with a brush for small additions. The effectiveness of the neutralization depends on how long or short the treatment is. The neutralization solution must never touch the rest of the drawing, as this would burn it irretrievably. The solution is then rinsed off thoroughly and the stone dried with a fan.

The artist is now free to add what he likes to his composition. Neutralization is a tricky technique as it alters or even destroys the structure of the stone's grain. It must therefore be used sparingly. After neutralization the whole business of pre-

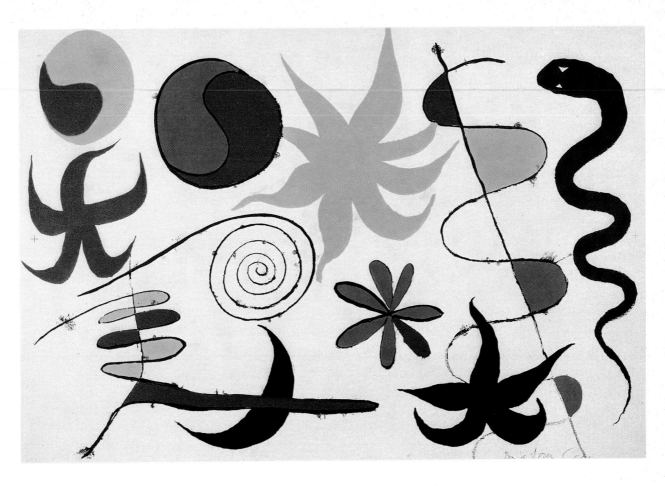

Alexander Calder, Serpent parmi les étoiles, *1969. Colour lithograph*

paring the stone must be started afresh. Trial proofs can then be printed.

The first proofs
It is the artist himself who decides on the number of trial proofs: he prints as many as he deems necessary for the success of the lithograph. He then examines them with the printer to see if any last minute modification to the set of the pressure or the inking up is required. The first proofs are usually printed on cheap ordinary paper, then a proof is printed on good paper to give a true idea of the effect of the composition. The artist writes his last instructions for the edition in the margin of this proof, along with a signed go-ahead which authorizes the lithographer to proceed with the final printing.

Marc Chagall checking a proof in the Mourlot workshop, Paris

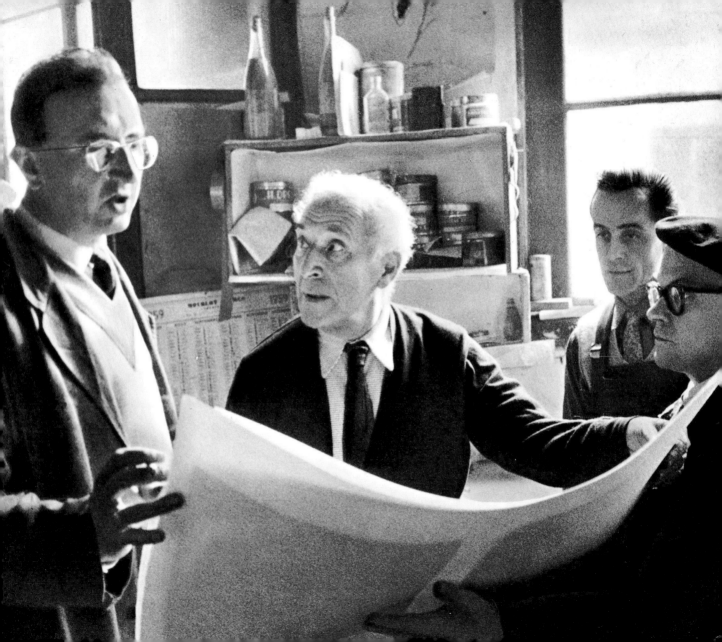

6 VARIATIONS ON LITHOGRAPHY

Colour lithography

After the discovery of lithography it was not long before printers started experimenting with daubing colours onto individual proofs after printing, as had been done with wood engraving. As early as 1816, however, Engelmann and Lasteyrie, two great lithographers of the period, introduced a new process: chromolithography, or colour printing. At first they were content with adding a second, bistre coloured block as a background for the black and white drawing. Later, brighter colours were added progressively, and the number of stones was increased until veritable facsimiles of paintings were produced. Technically these were brilliant achievements. The invention of this process paved the way for the extraordinary advance in poster making, which was to play such an important role at the end of the XIXth century.

Colour lithography, a very popular medium with contemporary artists, is a complex process which calls for a profound

Stones and proofs for colour printing
Composition by Denise Voïta

 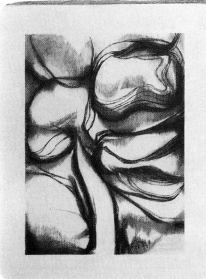 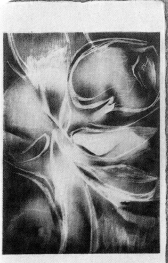

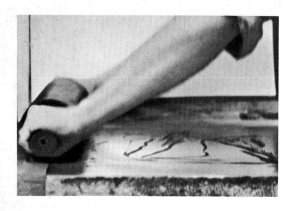

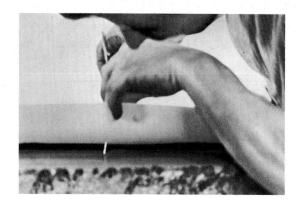

Inking up one of the colours

Registration with needles

knowledge of the theory of colour as well as the technique of lithography itself. This is why, once again, the artist who wants to produce colour prints will often rely on the help of a lithographic printer.

One stone is used per colour. The artist draws the elements of the composition corresponding to each colour on a separate stone which will be subsequently inked up with the appropriate colour. To do this, the same litho-crayon or litho-ink can be used on all the stones, as the point here is merely to have the drawing made in greasy matter.

Only the printing ink will change with each stone, according to the colour desired.

The artist's first job is to decide how many stones he needs for his composition. Using as a reference a fairly simple, full-sized sketch of the original design, often in gouache, he works out the different tones required. The contours of each colour are traced on a separate sheet of tracing paper. The artist lays the first sheet of tracing paper on the sketch, also known as a *rough,* and traces all the areas of red, say, that appear on the drawing. The first sheet is removed and another used for all the blue areas of the composition; this process is repeated until all the component tones have been separated.

Non-greasy drawing material is used for tracing. The various colours must then be transferred each to its respective stone using a very accurate form of *registration* so that the stones, which will all be used in succession to make the colour proof, tally. One old form of registration was to mark crosses in the margin. Today it is more common to rely on two small holes made with a needle at both ends of the stone.

The lithographer rubs the back of the

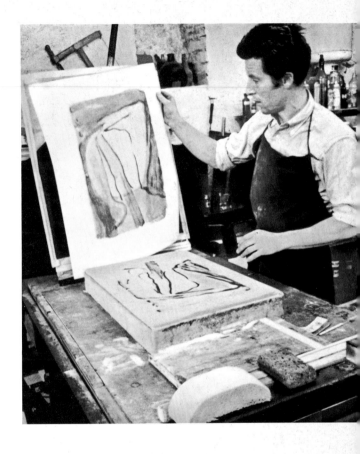

Printing one colour

63

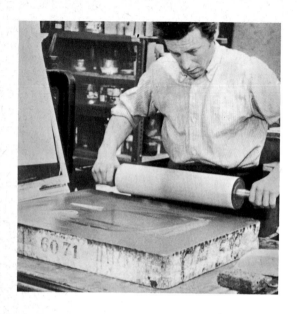

Inking up the next colour

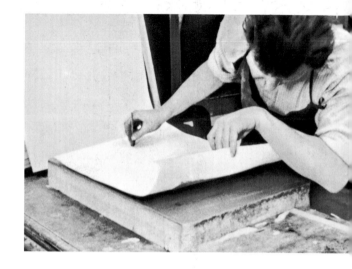

Registration

tracing paper with a Conté crayon and places it on the stone, blackened side downwards. Using a ball-point pen or a dry point, he then traces round the contours of the part to be transferred without pressing too hard, as excessive pressure will damage the stone or, by tearing through the paper, will leave pen marks on the stone which may appear in print. When the tracing paper is removed, the contour of the coloured area is clearly visible on the stone. The artist then draws in each colour separately, guided by the Conté transfer, using litho-ink or litho-crayon as he chooses. Once

64

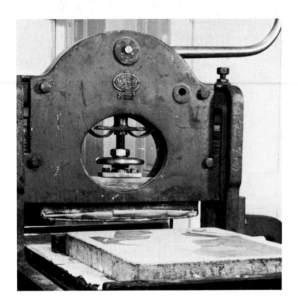

Printing

the colour areas have been filled in, the faint
Conté crayon outline on each stone is
erased.

When a proof of the first colour has been
pulled, the second stone is prepared and

Final proof

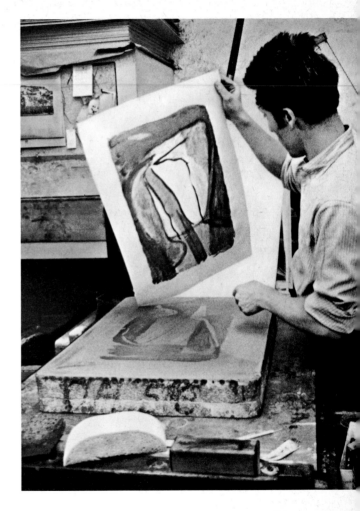

inked up, then a few trial proofs are printed. Now a print must be made with the two colours together. A proof of the first colour is registered on the second stone, which is already inked up, by lifting its edges one after the other, so as to guide the point of a needle into the hole previously pierced in the stone. When each needle is in its appropriate hole, the registration is accurate. The lithographer then puts the backing of paper and fibre-board in position, being careful not to move the printing paper, and pulls the lot under the scraper. In this way the second colour is printed well registered with the first. This operation is repeated for each further colour.

The preparation of the stone for colour is the same as for black and white printing, as the drawing is done with the same materials.

Transfers

It has long been the practice of many artists to use as a substitute for stone in lithography a special lithographic paper, called transfer paper, on which they draw with greasy crayon or ink. This is a very convenient process: transfer paper is easy to handle and transport; it also makes it possible for the artist to draw his composition the right way round. The original drawing is in fact transferred in reverse onto the stone, but reappears normally on the proof after printing. When all is said, however, working directly on the stone – although more demanding and calling for greater technical skill – produces results of a clarity and vigour that are hardly ever matched by transfers. This is why that masterful lithographer, Odilon Redon, often finished on the stone the drawing he had made on paper and then transferred.

Various sorts of transfer paper are available. The artist chooses the quality that will best suit the work he has in mind. As a rule, these papers are either opaque or transparent; they are grained and coated with a thin layer of size which receives the transfer proper.

Smooth paper, not unlike surface-coated paper, is sometimes used. A drawing made on this base with greasy autographic ink will produce, once transferred to the stone, a pen-and-ink print. This process, very fashionable in the XIXth century, was used by many newspapers and periodi-

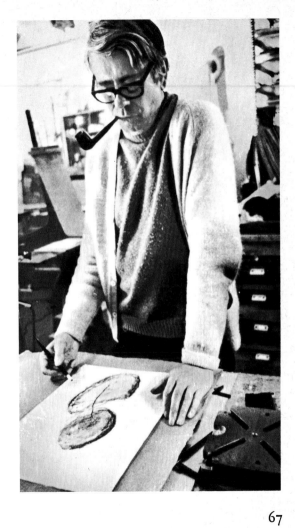

Pierre Tal Coat drawing a composition on transfer paper

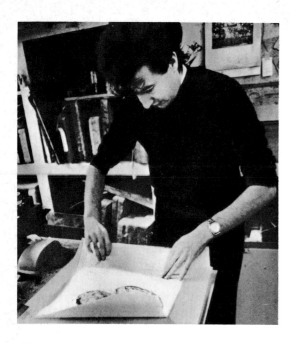

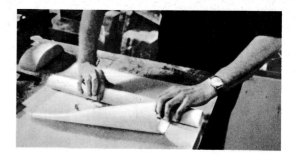

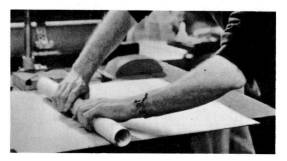

The transfer paper is moistened and rolled up

cals to produce cheap illustrations quickly.

Once the artist has completed his drawing on the transfer paper with litho-ink or crayon, he moistens the paper carefully with a sponge and rolls it in another sheet of paper so that it stays damp until it is used.

He then moistens the stone and places the transfer paper on it lightly. It is now again the paper's turn to be moistened before being covered with the usual backing of paper and fibre-board and pulled through the press several times. The transfer paper

The transfer paper is placed on the stone

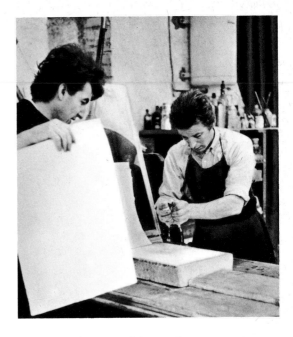

Moistening the stone and the transfer paper

must be remoistened each time. After several applications of pressure, the transfer adheres to the stone. The artist must then unstick the paper from the stone by dampening the back thoroughly with a sponge. A minute or two later he can peel the paper off easily with his finger-tips, being careful not to smudge the ink. When the paper has been removed, the stone is washed thoroughly to eliminate the gelatine coating and all traces of size, as these would hold ink and cause a hazy effect on printing.

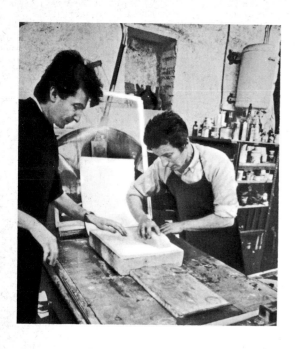

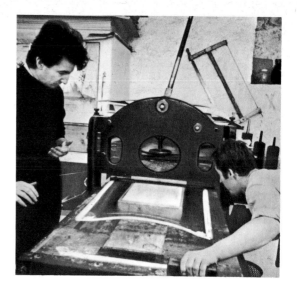

Moistening the transfer paper and running under the press

Then the stone is dried. Its preparation must be seen to immediately as the transfer remains very vulnerable until it has been inked and the stone has been gummed.

Zincography
The scarceness, high cost and clumsiness of lithographic stones have, for many years, caused some artists and lithographers to turn to zinc plates instead. In fact zinc has entirely supplanted stone for commercial printing. As early as 1818, Senefelder himself pointed out that all metals have the property of holding greasy matter, wheil non-greasy areas, if treated with acid and gum, repell printing ink.

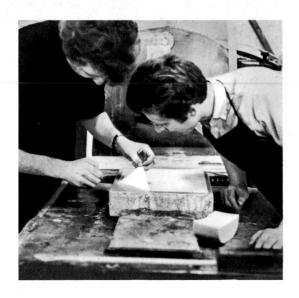

The transfer paper is unstuck

Zinc does indeed behave like stone when worked with litho-ink or crayon. The plates must be grained more or less finely depending on the nature of the composition for which they are intended.

The preparation of a zinc plate re-

The drawing is transferred to the stone

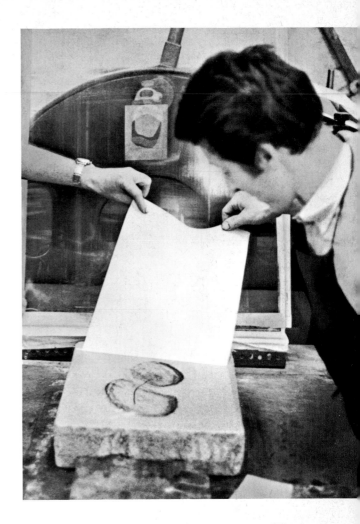

sembles that of the stone, except that a special mordant is used – basically phosphoric acid – which spreads in a thin film over the plate and absorbs water while preventing greasy ink from sticking to the non-printing areas.

Zincography, sometimes arbitrarily called lithography on zinc, is particularly suitable for wash drawing.

Lithographic engraving
During the XIXth century lithographic engraving was used commercially to produce, amongst other things, letter-heads and labels. It has recently begun to recapture the fancy of some artists. Albert Edgar Yersin, for instance, resorts to this fine, precise technique to create an imaginary universe, organic and topological, which is at the same time sensual, poetic and mysterious.

Only flawless stones can be used for litho engravings. They are not grained as for a lithograph, but finely polished with a grease-repellant mixture of gum arabic and salt of sorrel. The stone is rubbed with this paste until it shines brightly. The artist engraves the stone with a burin or a steel needle thus scratching out the top layer of the preparation. To make his work easier he has started by covering the stone with red chalk against which the engraved lines show up as white. When the engraving is finished it is covered with oil and the incisions are inked up with a dabber, the rest of the stone being protected by the gum arabic. The stone is then washed, after which the lines of the engraving stand out black.

Detail of an engraved stone by Albert Edgar Yersin

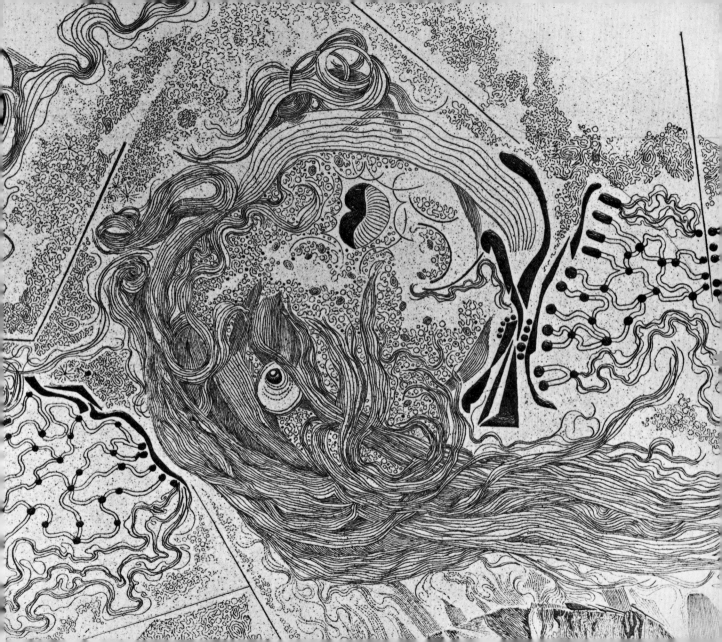

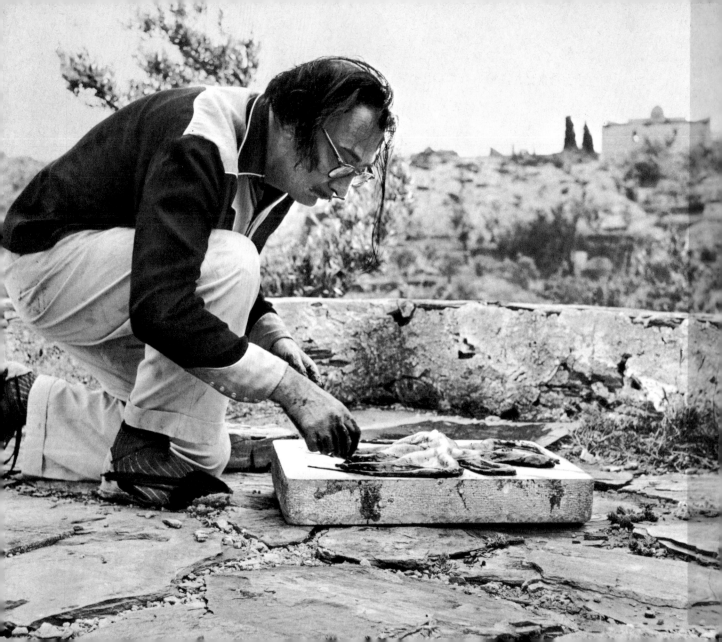

7 LITHOGRAPHY TODAY

Texture lithography

During the XXth century print-making has undergone the most important revolution in its history. Painters attracted by this art-form, and particularly by lithography which suits their temperaments so well, have, by refusing to become slaves to a technique bent it to their will to gain complete freedom of expression.

Lithography today, by combining and mixing various techniques, by modifying traditional materials and making room for unusual or unexpected textures, has expanded its potential almost without limits. Many a contemporary artist would agree with Martial Raysse, that: "in themselves techniques are not important, what counts is the use we make of them. A new vision of the world must be our starting point, from which a new vocabulary, new materials and a new way of organising space will spring quite naturally because the internal logic of the vision demands it."

One of the major contributors to the evolution of contemporary lithography is undoubtedly Robert Rauschenberg, who is

Salvador Dali prepares a texture lithograph

ready to use any accidental element from the outside world as an aid to creation. "All that can produce an image on the stone is potential material." He is interested in creating a fascinating contrast between transfers of coarse-textured newspaper illustration-blocks and the subtle grain of lithographic stone.

Antonio Tapies creates relief in his black and white and colour prints by running through the press objects which leave their embossed shape on the paper.

Roy Lichtenstein may use as many as six different techniques in the making of a proof, often combining lithography with silk-screen printing.

Jasper Johns adds richness to his compositions by making imprints with his hands. Other artists use plastic bases or photographic printing to produce texture, and sometimes burn the stone with acid to destroy its grain.

It has been said of the traditional techniques of graphic reproduction that they were found only after "a series of hesitant experiments, reversals and frustrations;" nevertheless, it must be admitted that the directions lithography has taken recently have greatly enriched the art of print-making with new and unlimited possibilities. Artists should, however, be careful not to use these innovations merely to perform dazzling technical feats and should instead relate them inseparably to their profound personal yearnings. The only valid criterion – authenticity – must be upheld at all cost.

Airbrush lithography
One new tool among the many employed by contemporary artists to make compositions on lithographic stone, is the *airbrush,* used by the Lausanne painter, Jean Lecoultre, who has given lithography a new impetus in yet another direction. It is a sort of atomiser that sprays ink by means of a jet of compressed air. Lecoultre explained in an interview that, in fact, he discovered this tool quite by chance: "a friend of mine suggested one day that I should use this technical process for painting. It turned out to be just what I was looking for without knowing it . . . this instrument produces

Jean Lecoultre, Rendez-vous, *1970. Airbrush lithograph*

Robert Rauschenberg,
Water Stop, *1968. Colour*
lithograph

a Frenchman called Barclay patented a machine for printing on tin. It consisted of a cylinder covered with smooth carboard which transferred a drawing from a zinc plate. In 1876, one Guillot, from Paris, thought of rolling sheets of paper between two cylinders, one of which held the zinc, the other a linen packing. Finally towards the end of the century Champenois invented a cylinder machine which printed on paper and cloth by a transfer method. Actually, all that these machines did was to increase the speed of lithographic printing. The first offset presses only made their appearance around 1904. Their invention is generally attributed to the American, I.W. Rubel.

Senefelder's lithographic press, with its hand-operated scraper, was replaced as early as 1850 by a mechanical press called a "lithoplate", which, to look at, ressembles a letter-press machine. The stone is fastened to a marble bed that moves to and fro, while a sheet of paper is lowered onto the moving stone by the cylinder to which it is attached. Two rollers ink up and moisten the stone in turn.

Both offset and lithography are based on the same principle: the repulsion of greasy particles by water. There are, however, three distinct differences between the two processes: in offset, the heavy, cumbersome litho stones are no longer needed; instead the printing base is made from supple sheets of metal, usually zinc or aluminium. Also, offset is no longer a direct printing method, since a rubber cylinder acts as intermediary between zinc and proof. As a result the composition is the right way round on the metal plate. Finally, offset machines are not flat but rotary, made up exclusively of cylinders. To sum up: the offset process consists of printing on a rotary machine using a metal plate which is prepared the same way as in lithography. The inked up composition on the plate is transferred to a rubber roller by which it is in turn printed on the paper. Non-printing areas on the plate are kept moist.

Offset machines comprise three main cylinders: the upper cylinder holds the zinc plate with the composition, the middle cylinder – a rubber roller, sometimes known as a *blanket-cylinder* – transfers the impression of the composition to the bottom cylinder, called the pressure cylinder, which supports the paper during printing.

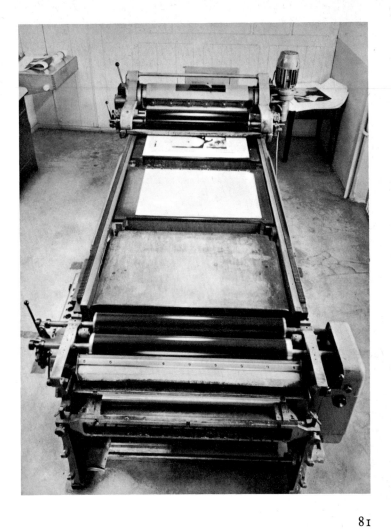

Proofing press

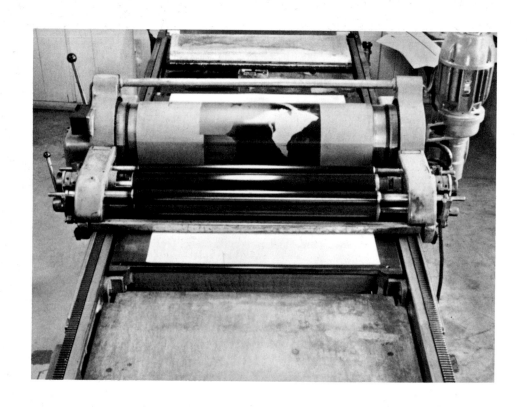

Blanket and inking roller *Plate and printed work*

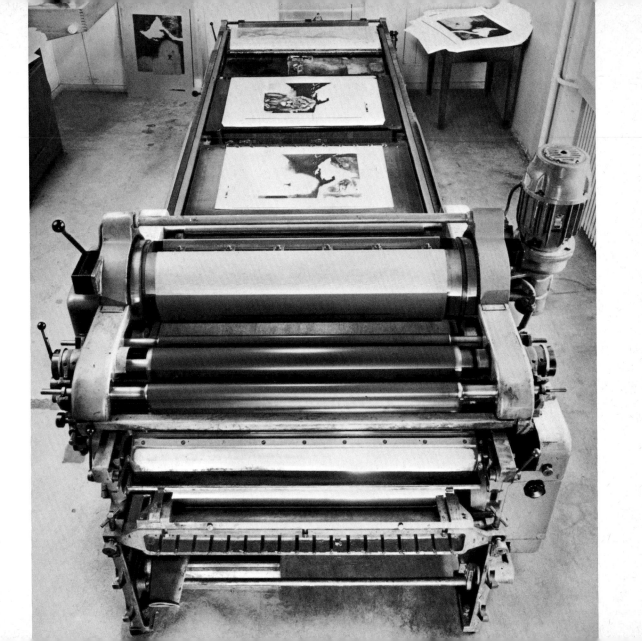

When printing starts, the plate is moistened by a plastic roller and then inked up. The ink is conveyed from an ink-trough by a series of rollers, some of which are made of copper-plated metal, the others of rubber or plastic. The composition, thus inked up, is picked up by the middle cylinder and transferred onto a sheet of printing paper.

There are various models of offset press: the simplest is only suitable for monochrome printing and has the three traditional cylinders. It sometimes requires inking up and moistening by hand. Another model comprises two rubber rollers that print on both sides of the paper at the same time by exerting a counter-pressure on each other.

Two colour or four colour presses are also found. The disposition of the cylinders varies from model to model.

The quality of an offset print depends essentially on the balance between ink and moisture because it is always difficult to keep up an even inking with greasy ink. Highly-saturated inks are necessary. Offset printing can be used for all lithographic work: both original work and photomechanical transfers can be put to zinc. Offset, which was originally only a variation on lithography, can now cope with work once reserved for typography.

Printing on a machine

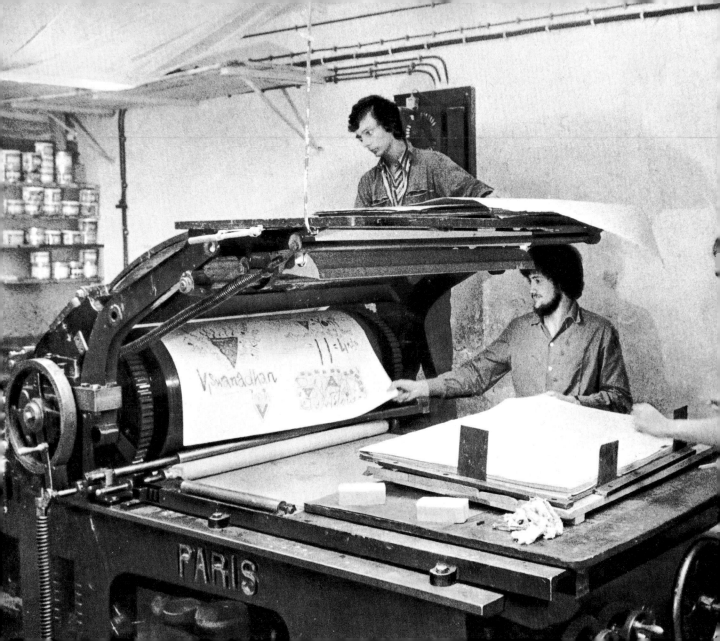

8 THE HISTORY OF LITHOGRAPHY

An invention

Lithography, which was discovered at the beginning of the XIXth century, cannot be considered in isolation from the other scientific developments of the age, for these in some ways played a part in its invention.

It was in 1796 in Munich, that the author of rather mediocre plays for the theatre, Aloïs Senefelder (1771–1834), discovered the process. Being a man of slender means he was looking for inexpensive ways of publishing his own writings. Copper was too dear, so he tried stones excavated from the Solenhofen quarries in the Isar valley, and attempted to engrave his text by tracing it backwards with a brush dipped in greasy varnish. He then treated the surface of his slab of limestone with acid to etch the areas unprotected by varnish, using, in fact, the etcher's technique. But Senefelder's

Honoré Daumier, Monsieur Daumier votre série est charmante, *1838. Black and white lithograph*

great discovery, which he came across by chance, was that it is still possible to print a text even if no relief is given to the stone. He perfected a sort of greasy crayon – the composition of which he described in his treatise on lithography – with which to trace letters on the stone. The process, he thought, could be applied to the reproduction of musical scores and in 1799 he entered into partnership with Johann Anton André, the music editor from Offenbach. It is interesting to remember that lithography was not originally intended to be a medium for the fine arts, but was considered as no more than a way to reproduce writing or musical script.

Senefelder continued to work on his invention and improve it; in 1800 he deposited "a complete description of lithography" at the London patent office. In 1806 he founded the Senefelder, Gleissen & Co. printing works with baron von Aretin. As so often happens with important discoveries the authorship of the invention was soon hotly disputed. Senefelder himself examined, in a book first published in Munich but soon followed in 1819 by French and English translations, the con-

tradictory rumours which claimed that Schmidt, among others, had already experimented with the same idea. Schmidt may have printed on stone, but his methods were very different from those of Senefelder, who must undoubtedly be acknowledged as the founder of what he himself called chemical lithography, which he defined as follows: "it matters relatively little whether the design is hollowed out or in relief. What is essential is that the lines and dots made on the slab selected for printing should be covered with matter that attracts ink by its chemical affinity, according to the laws of attraction. The chemical composition of the ink and that of the design must therefore be similar: moreover the parts of the stone that are to stay white must have the property of repelling ink in order to prevent its adherence."

The development of lithography was in fact the result of the common efforts of French and German lithographers. Johann Anton André, the descendant of a French Huguenot family, went to Paris where he was granted a ten-year patent for "a new method of engraving and printing." Having kept his German nationality he could not run a printing-works in Paris under his own name. He had to find people willing to lend their names to the enterprise. Charles Philibert de Lasteyrie du Saillant (1759–1849) went to Munich in 1812 to study the new process, and established the first lithographic printing works in Paris in 1816. Godefroy Engelmann (1788–1839) had opened a workshop at Mulhouse in 1814, and in 1817 Charles Motte established himself in Paris; the year 1818 saw prints by Charlet and Géricault published by Delpech. By and by the technique was perfected and prints improved in quality. Illustrious amateurs like the duchesse de Barry, the duc de Bordeaux, Queen Hortense and Vivant Denon took up lithography.

From then on the perfectionment of the lithographic process went hand in hand with the evolution of the printing press, the oldest of which – Mitterer's roller press – had been used by Senefelder for his first trials.

The early history of lithography, which

Pierre Bonnard, Maison dans la cour, *1899. 4 colour lithograph*

89

was invented on the eve of the French revolution, can be subdivided into three distinct periods: during the first period, despite the appearance of artistic lithographs in England as early as 1800, editors concentrated on the commercial applications of the new process. Then from 1810 onwards artistic lithography came into its own; it was used to reproduce drawings and paintings by the masters. A few painters, however, and notably Goya, adapted lithography to suit their personal artistic preoccupations. A few years later it became the instrument of the press, the mouthpiece of public opinion. Finally, the introduction of colour, which Toulouse-Lautrec exploited so brilliantly in his masterly posters, gave it a spectacular new lease of life.

Word of the new graphic technique being used in Senefelder's workshops soon spread to the artistic centres of Europe – even as far as Spain. In Madrid, Francisco Goya (1746–1828), one of the greatest printmakers of his time, tried out the new process.

Goya made his first lithographs in 1819, the year that Senefelder's treatise was published in French and in English. He mastered the technique very quickly. It was as an exile in Bordeaux, where he settled in 1822, that three years later, he produced the famous series of four lithographs called the *Taureaux de Bordeaux*. They were printed by the able lithographer Gaulon, of whom Goya made an admirable portrait.

These powerful compositions were drawn directly onto the stone with a freedom and energy that have only been equalled by Daumier in some of his works. By the richness and wide range of tones and the variety of blacks he employed, as well as by his use of the scraper for shaded areas, Goya proved that he knew how to exploit the possibilities of the art to the full.

Lithography was a favourite technique with the early romantic artists. The twenty-five volumes of a monumental work called "*Les voyages pittoresques et romantiques dans l'ancienne France*", written by Charles Nodier and Alphonse de Cailleux and illustrated by a number of artists selected by baron Taylor, was widely acclaimed as a model of French lithography. It was started in 1820 and completed in 1878. Richard Parkes Bonington (1801–1828), the young

English-born artist who spent most of his life in France, participated in the work for the first time in the collection of prints published in 1824. He was one of the most important lithographers of the period. His delicate *Paysages citadins* continued to inspire artists long after his death.

The versatile litho crayon was as often used for portrait work as it had been for landscape; iconographic works like *Les Galeries de célébrités* and *Les Panthéons d'hommes illustres* were common. On the whole these collections remained anecdotal with the exception of a few prints by Achilles Deveria (1800–1857).

One of the most enthusiastic adepts of romantic lithography was certainly Théodore Géricault (1791–1824), who wrote to his friend Dorcy in 1821: "I lithograph powerfully". He used the process from 1817 onwards, sketching street scenes on the stone with a lively crayon, and using wash and scraper with extraordinary dash to produce his *Etudes de chevaux*.

Another romantic artist, Eugène Delacroix (1789–1863), was attracted to litho-

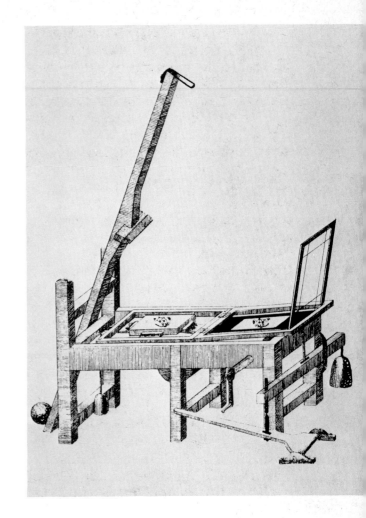

Aloïs Senefelder's press

graphy while still very young. He must have been initiated to the art by Charlet, to whom he devoted a most flattering article in *La Revue des Deux-Mondes* in 1861. He also knew Géricault's admirable lithographs published in London in 1821. It was in fact during a visit to London in 1825 that Delacroix found a suitable background for scenes from Byron that had long been haunting his imagination; in the melancholy English mists he saw the spirits and demons that peopled the castles of his dreams, to which he was later to give form in *Macbeth chez les Sorcières*. Back from England, he struck up a friendship with Achilles Deveria, who, being bent upon illustrating Goethe's Faust, asked Delacroix to design the cover. Bersier said of this visionary work, with its seventeen plates: "it has left its stamp on pictorial romanticism much as (Hugo's) preface to *Cromwell* marked romantic literature." Delacroix treated this work in a very personal way, using the text freely so as to transcend it with the originality of his own vision. As Goethe found himself bound to admit: "I must own that Mr. Delacroix has surpassed the way I had pictured my own scenes; the

Richard Parkes Bonington, Le silence favorable, *1826. Black and white lithograph*

Eugène Delacroix, Faust et Méphistophélès galopant dans la nuit du sabbat, *1828. Black and white lithograph*

reader should certainly find that these illustrations, so full of life, go further than his own imagination."

A political weapon

Lithography was for several years closely associated with the development of the press, in which visual images had come to play a capital role. In the hands of artists like Daumier, a man of vision highly critical of contemporary society, it became a formidable political weapon.

The 1830 revolution had given the Republicans reason to hope for a permanent victory. After the July rising when the revolution had been crushed and Louis-Philippe was on the throne, there was great popular ill-feeling towards the new king. Charles Philipon, the founder of the weekly newspaper *La Caricature* and the daily *Le Charivari*, was prompt in recognizing Daumier's genius. He lost no time in taking him on as an invaluable collaborator skilled at giving pictorial expression to the anger mounting in Paris and France against the regime's policies. Daumier was to be a devoted ally in what was called "Philipon's war on Philippe".

He contributed regularly and abundantly to *La Caricature,* until the periodical was forced to discontinue in August 1835 as a result of the suppression of the liberty of the press. Philipon then asked the artists working for him to produce larger scale compositions on stone, which he published under the title *L'Association Mensuelle.* They were sold at one franc per proof. Included in this collection were four of the most important works in the history of print-making, Daumier's *Le Ventre législatif, Ne vous y frottez pas, Enfoncé Lafayette* and the tragic splendour of *La rue Transnonain.*

Forced to give up political caricatures for a while, Daumier turned his critical gaze onto the moeurs of his fellow citizens, of which he painted a clear and truthful picture devoid of any complacency.

During the crisis of 1848 he became irresistibly involved in politics. As an ardent supporter of the Republican cause, he exercised his verve against first Dr. Vernon, then Thiers, Montalembert, Léon Faucher and all those who wanted to restore

Honoré Daumier, Rue Transnonain, le 15 avril 1834. *Black and white lithograph*

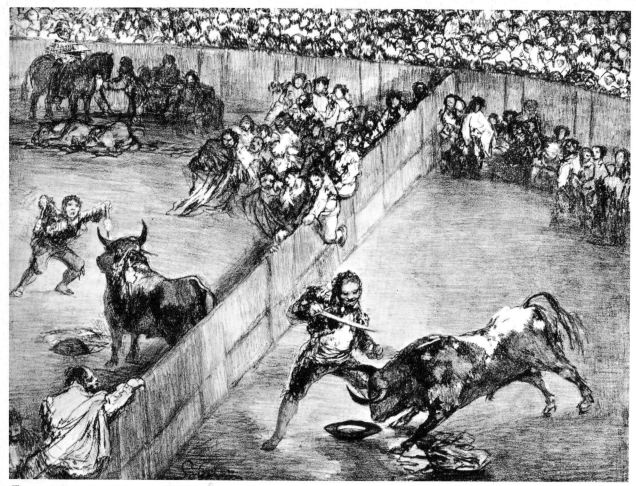

Francisco Goya, La division de la Place, *1825. Black and white lithograph*

96

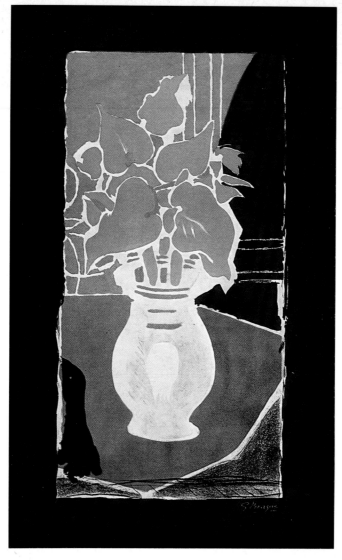

Georges Braque, Feuilles,
couleur, lumière, *1953*.
4 colour lithograph

97

monarchy or re-establish the empire. He gave up political satire once again after the coup d'état of the second of December 1851, which caused the fall of the Republic.

Daumier turned lithography into a weapon with which to fight power and hypocrisy. His prolific output – he made about four thousand lithographs – is the work of a visionary; a fresco of mankind in which bourgeois and ne'er-do-wells, workers, judges and politicians stand side by side in tumultuous co-existence.

After such a promising start, lithography lost some of its brilliance during the middle years of the century, and entered a dull period. It became steadily commercialized until Odilon Redon (1840–1918) chose the technique as a means of expression, and used its resources to the full, showing extreme independence and innovating knowledgeably with happy results.

The lithographic work of this "poet of the fantastic" reveals to the spectator an art of extraordinary subtlety, in which pitch-black depths are shot through by mysterious shadows and occasional flashes of light. Redon found a subject worthy of his imagination in his Temptations of St. Anthony,

a work which was inspired by Gustave Flaubert's text; he concentrated, however, on the plastic possibilities of the Flaubert, which he treated with great originality. Mallarmé, the leader of the Symbolist movement, whose mind was involved in very much the same spiritual quest, much admired the prints. He was to say: "You beat the wing-feathers of dreams and night in our silent depths. I am fascinated by it all, as these fantasies are your very off-spring. The depths of your imagination are as deep as the deepest black; as you know, Redon, demon lithographer, I covet your fables."

Artistic lithography in France sprung to life again during the last few years of the XIXth century, thanks to the first serious application of colour printing, which had been rarely used so far, although the process was known from the beginning. Colour printing gave birth to a new art-form – the poster, which took root under Jules Chéret (1836–1933) and blossomed splendidly with Toulouse-Lautrec.

The first posters were made in London, where Chéret studied the art. Back in Paris, he caught the eye of the public with posters

like his *Moulin Rouge,* which also impressed Toulouse-Lautrec.

Lautrec, a man of genius, fell in love with lithography and carried it to its highest level of perfection. He supervised the printing of his colour plates himself, always destroying all proofs that failed to come up to his exacting standard. His first poster came out in 1885: an illustration for Aristide Bruant's song *A Saint-Lazare.* From 1891 onwards he worked for Roques' *Courrier Français,* and started the series of well-known posters that included his first colour lithograph, his own *Moulin Rouge,* which was commissioned by Zidler.

The *Estampe originale,* which came out in 1893, was intended to be both a review and a movement to bring together artists who were interested in engraving and in making original lithographs, thus discrediting the business of printing reproductions of paintings. For the cover-design, Toulouse-Lautrec used portraits of Jane Avril, who had already modelled for his paintings, and of *le père* Cotelle, printer at the Ancourt

Odilon Redon, Je suis toujours la grande Isis, *1896. Black and white lithograph*

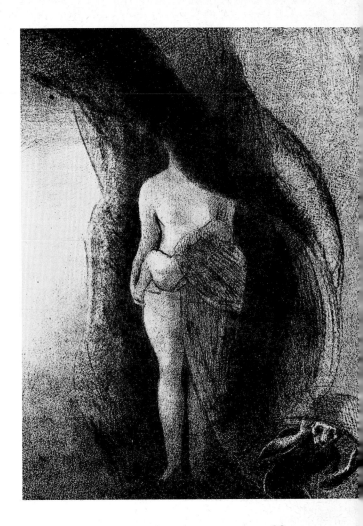

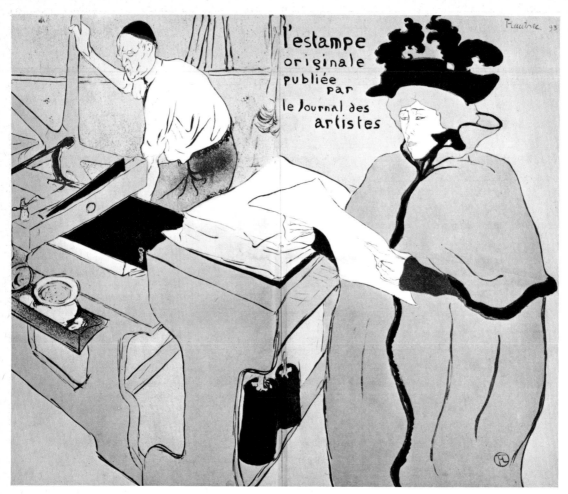

Henri de Toulouse-Lautrec, cover of L'Estampe originale, *1893. Colour lithograph*

100

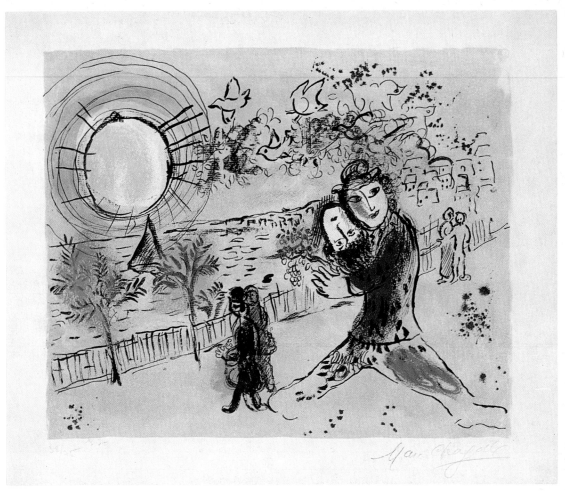

Marc Chagall. Le soleil jaune, *1968. Colour lithograph*

printing-works, where he had most of his lithographs printed. It was in fact Bonnard who introduced Toulouse-Lautrec to the famous printer.

Toulouse-Lautrec's posters were immediately acclaimed by the man in the street, and with reason: they revolutionized advertising art. Going further than Chéret, he laid down the rules of modern poster-art, using bold compositions, splatter technique and large flat areas of colour with clear outlines.

In 1896 he started work on thirty-odd lithographs mostly on themes that he had already explored in his paintings, as for instance the album *Elles,* which is devoted to the inmates of the *maisons closes.* It is difficult to know what to admire most in this series, in which economy of means and subtle colouring converge most effectively.

In 1893, Toulouse-Lautrec embarked on a series of black and white lithographs that he was still working on at his death. His technique is dazzling: from a mixture of bold, flat areas of black, strong brush-marks and wash-drawing, as in *Ultime Ballade,* he soon moved on to astonishingly fine and light crayon drawings.

Undeniably, Toulouse-Lautrec's lithographic work had an influence on modern art, but other artists of the 1890's, mostly gathered round the editor Ambrose Vollard, also became interested by the art and the renewed attraction of print-making. Bonnard, Vuillard and Maurice Denis stand out from the group. Pierre Bonnard made his first poster, *France-Champagne,* in 1890. He subsequently had work published in the *Estampe originale,* produced posters for *La Revue Blanche* and created for Vollard an album of twelve lithographs called *Quelques aspects de la vie de Paris.* He also illustrated Verlaine's *Parallèlement* and Longus' *Daphnis et Chloé.* In each of his compositions he managed to find the right colour harmony that would give his drawing shape and volume. As for Vuillard, he started with black and white lithographs that were printed by Ancourt, but he soon turned to colour, which he had well-mastered by the time the album *Paysages intérieures* was published in 1899. His quiet, refined work relies on discrete touches of delicate colour. Lastly, Maurice Denis proved himself to be a great lithographer with the suite *Amour,* dated 1899.

Other artists were attracted by the technique: Henri-Fantin Latour (1836–1904), Eugène Carrière (1849–1906) and the Norwegian Edvard Munch (1864–1944), who worked for a time at the Clot workshop in Paris – his *Scream* has unparalleled power and violence. Several German artists: Max Slevogt (1868–1932), Max Liebermann (1847–1945), Lovis Corinth (1858–1925) and Oskar Kokoschka (1886–), influenced by French lithographers, and above all by Toulouse-Lautrec, took up lithography. The members of the group *Die Brücke*, having re-established wood engraving as a respectable art-form, also took an interest in Senefelder's process – Emil Nolde in particular. Werner Haftman said of the latter's lithographs that they "are the acme of German expressionist graphic art."

Lithography has captivated a great many modern and contemporary artists. Henri Matisse (1869–1954) tried out the technique in 1904, undoubtedly influenced by the works of Toulouse-Lautrec, Bonnard and Vuillard. Sticking to black and white, he

Henri de Toulouse-Lautrec, Leloir et Moreno dans les Femmes savantes, *1894. Black and white lithograph*

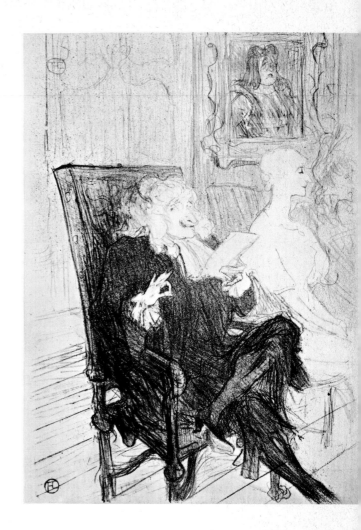

would either make highly elaborate draw-
ings or, as in his odalisques, be content with
suggesting the volumes of the human body
with skilfully graduated greys, now giving
his compositions, as he put it himself "an
expansive force that animates surrounding
objects; now, on the contrary, fitting airy,
transparent forms into precise, stripped
down designs."

Braque's themes remain constantly
sober; he remarked "I have tried a new
style, practically turning my lithographs
into paintings, instead of sticking to the
traditional hightened drawing." Marc Cha-
gall turns his stones into a feast of joy and
colour, while Miró describes on his a world
of dreams and fantasies. Finally, who could
be better qualified than Picasso, with his
unrivaled technical skill, to demonstrate, if
necessary, that lithography is still alive?

Matisse Henri, Danseuse, *1931/1932. Lithograph*

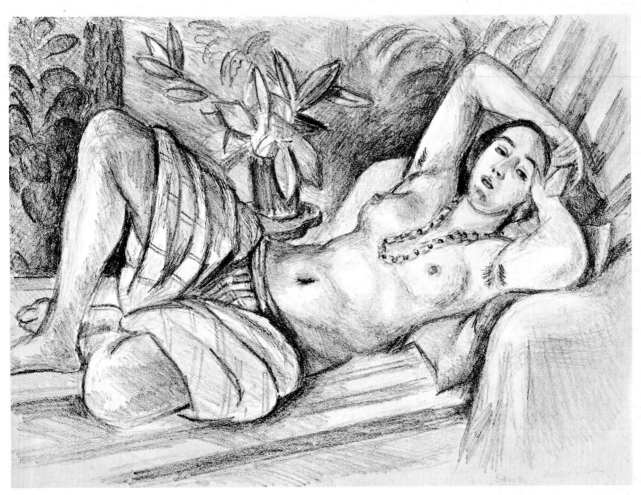

Henri Matisse, Odalisque aux Magnolias, *1923. Black and white lithograph*

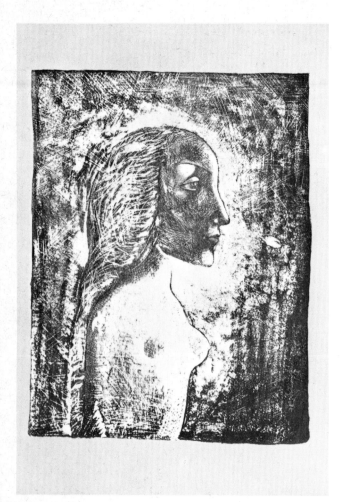

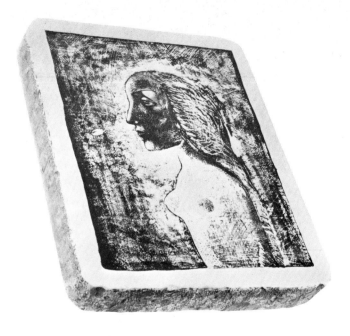

Jorge Castillo, Marienza illuminée, *1968. Black and white lithograph*

9 HINTS FOR THE COLLECTOR

The art of lithography, as it was understood in the XIXth century, has undergone a remarkable evolution. As interest in prints and their commercial distribution continues to grow, contemporary collectors need greater technical knowledge if they are to acquire works with discernment.

Printing
There are various successive stages in the printing of a lithograph. The collector should be able to recognize the proofs corresponding to each stage.

States
These are always prints that have been pulled from an unfinished composition. From one state to the next the artist may want to change his drawing or the density and colour of the ink. Some artists, notably Toulouse-Lautrec and Picasso, have made radical changes to their works at this stage. The state of the proof is usually mentioned under the picture (1st state, 2nd state, and so on).

Trial proofs
Trial proofs are usually printed by the artist, sometimes in collaboration with the printer, to work out the requirements for the best possible printing: the quality of the ink, the choice of paper, the degree of pressure. The proof that is chosen as a model for the edition is duly authorized by the artist.

Artist's proofs
It is unusual for more than ten artist's proofs to be pulled. Officially they are not

for sale, but intended for the artist's private collection or for copyright purposes. The words "Artist's proof" are written under the right hand corner of the print. Initials are sometimes used, such as E.A. (*épreuve d'artiste,* French for "Artist's proof") or H.C. (*Hors commerce,* French for not for sale).

Over copies
These are proofs printed over and above the limit of the edition to replace any poor-quality impressions that the artist has decided to destroy.

Unedited lithographs
This is the term applied to the few existing prints from a composition that the artist has, for one reason or another, decided to abandon.

Numbering the edition
When the printing of an edition is completed the prints are numbered at the bottom left-hand corner; the number of the

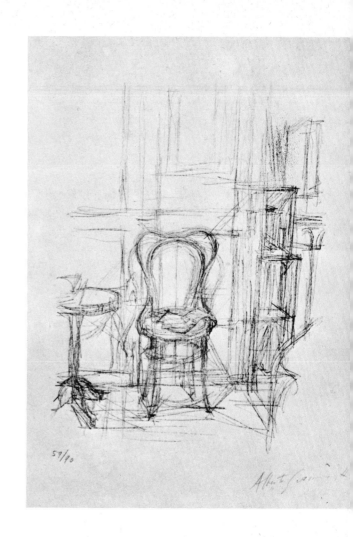

Alberto Giacometti, Chaise et guéridon, *1960. Black and white lithograph*

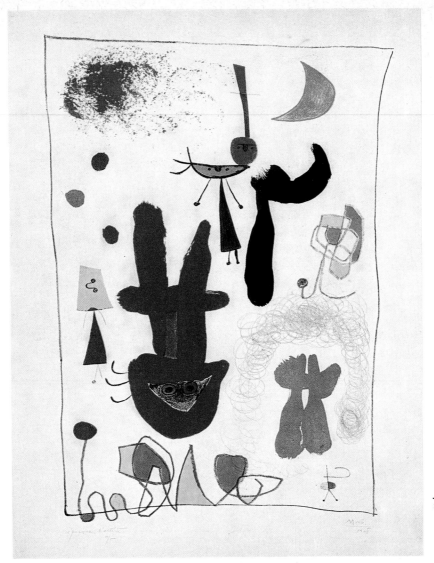

Joan Miró, Acrobates
au jardin de nuit, *1948.*
Colour lithograph

109

particular print is noted next to the size of the whole edition (for example: 5/75), and signed by the artist under the right-hand corner of the picture. This done, the stone must be crossed out.

Original lithographs and reproductions

For several years experts have been trying to formulate a full and precise definition of the original print, whether it be a woodcut, a burin engraving, an etching or a lithograph. Texts intended to enlighten collectors have been published in 1960 by the International Congress of Artists in Vienna, in 1964 by the *Comité national de la gravure française,* and by the Print Council of America and in 1969 by the International Guild of Lithography at Ostend.

A distinction must be made between the three totally different categories commonly lumped together under the vague title "Prints": original lithographs, hand-copied lithographic reproductions of an artist's drawing and photomechanical reproductions.

An original lithograph must fulfill the following conditions: it must be entirely the work of the artist himself, and it must be printed on a hand press. Prints carried out by a lithographer after an artist's drawing are, in fact, not considered as original works of art; they are reproductions. They may, however, be described as "original reproductions". They are the work of able craftsmen. Unfortunately, certain contemporary artists are in the habit of signing and numbering these prints.

Finally, there are reproductions, known as original prints, which are produced photomechanically then reworked and retouched by hand.

The originality of a lithograph is assured by the use of a hand press, because the artist can supervise the printing of each proof to check the intensity of the black or coloured inks. In this way some variation occurs between successive prints. It is, however, impossible to interfere in the process of mechanical printing, so every sheet of paper undergoes exactly the same treatment.

Obviously, then, the collector should be well informed and exacting when acquiring a print, to avoid being misled by a famous signature under what could be a mere reproduction.

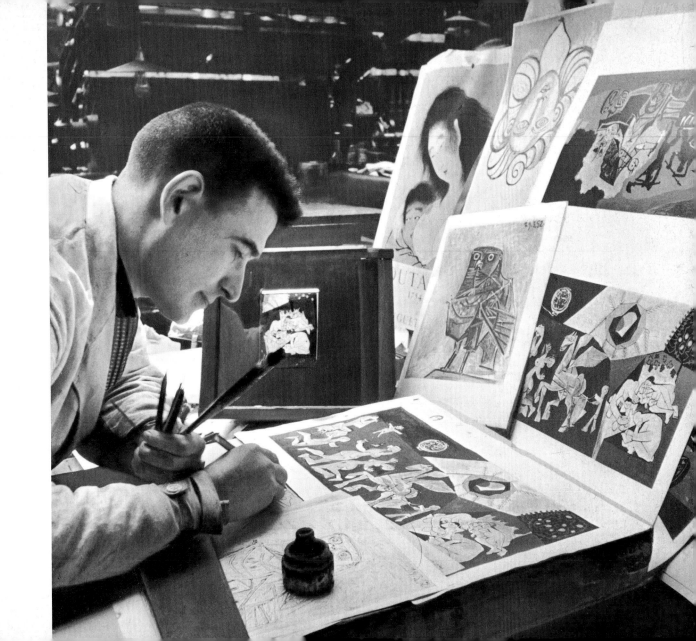

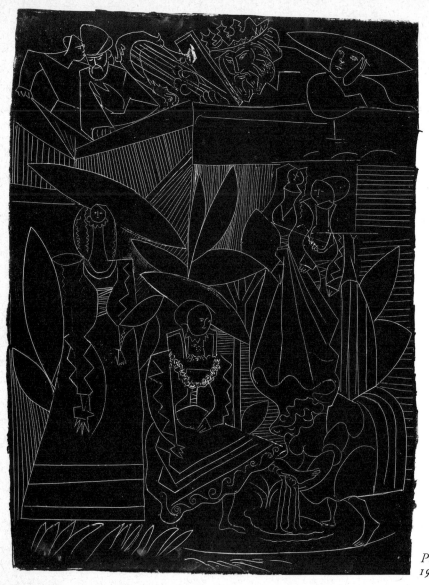

Pablo Picasso, David et Bethsabée,
1947. Black and white lithograph

SYNOPSIS

Lithography	The Arts	General
1771 Birth of Aloïs Senefelder		
1796 Invention of lithography	Birth of Corot	Risorgimento in Italy
1799	Goya's *Caprices* published	Bonaparte elected First Consul
1800 Senefelder deposits "a complete description of lithography" at the London patent office		
1805– 1807	David paints *Le Sacre de Napoléon*	Jacquards invents the silk-weaving loom
1806 Senefelder, Gleissner & Co. printings-works founded by Senefelder with baron von Aretin	Death of Fragonard	End of the Holy Roman Empire
1810 First experiments in colour-lithography Lithography is used to reproduce drawings and paintings by the old masters	Goethe's "Theory of Colour" published	Censorship re-established in France
1816 Charles Philibert de Lasteyrie du Saillant sets up a lithographic workshop in Paris		
1817 First lithographs by Géricault		

Lithography	The Arts	General
1818 Senefelder's "Complete Course of Lithography" published. Delpech prints works by Charlet and Géricault		Madame de Staël "*Considérations sur la Révolution française.*"
1820 First volume of "*Voyages pittoresques et romantiques dans l'ancienne France*"		In England, coronation, of George IV
1824 First lithographs by Richard Parkes Bonington	Eugène Delacroix paints *Le Massacre de Scio* Exhibition of English painters at the Salon de Paris	
1825 Goya lithographs *Les Taureaux de Bordeaux*		
1828 Delacroix illustrates Goethe's *Faust*	Death of Goya	
1830 Daumier's lithographs in *La Caricature* and later *Le Charivari*	Birth of Pissarro	July revolution in France: Triumph for liberal bourgeoisie
1834 Great lithographs by Daumier: *Le ventre législatif,* *La rue Transnonain*	Birth of Degas Delacroix: *Femmes d'Alger*	Slavery abolished in England
1837 Engelmann has his "lithocolour printing or colour lithography imitating painting" process patented	Death of Constable	Beginnings of a popular press in France
1848	Pre-Raphaelite Brotherhood formed round Rossetti	February revolution in France Second Republic
1850 Parisian lithographer Firmin Gillot patents a process for engraving designs on zinc		

Lithography	The Arts	General
1857	Baudelaire's *Les Fleurs du Mal* published	
1871 *La barricade*, lithograph by Edouard Manet	Gauguin starts painting	Commune proclaimed in Paris
1872 Last lithographs by Daumier		
1874	Impressionists exhibition in Paris	
1881		Process-engraving invented by Meisenbach
1885 Toulouse-Lautrec's first lithograph: *A Saint-Lazare*	Van Gogh paints *The Potatoeaters*	
1889	Nabis group formed. *La Revue Blanche* published	
1890 Bonnard's first poster: *France-Champagne*	Van Gogh commits suicide	
1891 *Le Moulin Rouge*, poster by Toulouse-Lautrec	Paul Cézanne paints *Les Joueurs de cartes*	Colour photography discovered
1893 *L'Estampe originale* is published. Cover-design of the first edition by Toulouse-Lautrec	Sezession movement created in Munich	
1895 *Scream*, lithograph by Edvard Munch	Rodin sculpts *Les Bourgeois de Calais*	First cinematographic projection by the Lumière brothers
1896 Odilon Redon illustrates Flaubert's "*La tentation de Saint-Antoine*"	Munch has a stay in Paris	
1899 Edouard Villard's *Paysages intérieurs* and Bonnard's *Quelques aspects de la vie de Paris* are published	James Ensor exhibition in Brussels. Publication of Signac's work on Neo-impressionism	

Lithography	The Arts	General
1905	Advent of Fauvism. Creation of the "Die Brücke" group	Einstein discovers the theory of Relativity
1907 Emil Nolde carries out a series of brush lithographs	Picasso paints *Les Demoiselles d'Avignon*	
Circa 1910 Georges Rouault turns to the renewed art of colour lithography	Manifesto of Futurist Painting	
1916	Dada movement founded in Zurich	
1916– 1917 Ernst Barlach illustrates his own play *Der Tote Tag* with 27 lithographs		
1921 Georges Braque's first lithograph: *Nature morte : verre et fruits*	Miró exhibition in Paris In Moscow Kandinsky founds the Academy of Arts and Sciences	
1922 Max Beckmann's series *Berliner Reise* published	International Dada exhibition	Russia becomes the Union of Soviet Socialist Republics Fascism in Italy
1924	The review *Les Cahiers d'Art* founded by Zervos	Hitler's *Mein Kampf* published
1928 Henri Matisse's series: *Danseuses*		
1929	Aeropainting manifesto	Collapse of the New York Stock Exchange
1933 Graham Sutherland's first lithographs	Matisse paints *La Danse*	Nazis put an end to the activities of the Bauhaus
1944 Picasso meets Mourlot in Paris and starts to make lithographs in his workshop	Russells *History of Western Philosophy* published	Allied landings in Normandy De Gaulle restores the Republic

Lithography	The Arts	General
1946 Picasso devotes a series of lithographs to Françoise Gillot	Retrospective Chagall exhibition at the Museum of Modern Art, New York	
1946– *Graphische Figurationen* by 1947 Willi Baumeister, 10 lithographs. One of the first publications of the kind in post-war Germany		
1948 Fernand Léger creates a series of colour lithographs for Kahnweiler	Foundation of the "Cobra" group	
1949 Braque carries out an 8 colour lithograph: *Théière et citrons*. Miró illustrates Tristan Tzara's *Parler seul* with 72 lithographs	Foundation of the review *L'Art d'aujourd'hui*	
1954 Pablo Picasso, *Poèmes et lithographies*. A series of 40 compositions and 26 pages of text, in the artist's own hand.	"Tachisme" is born	
1956– Chagall makes lithographs 1960 for *La Bible*		
1957– Jean Dubuffet creates the 1962 lithographic suite *Les Phénomènes*		
1958 Braque makes lithographs for René Char's work "*Lettera amorosa*" Dubuffet sets up a lithography workshop		Fifth Republic in France
1959 *Derrière le Miroir* by Braque, 9 colour lithographs	Inauguration of F.L. Wright's Guggenheim Museum in New York	

Lithography	The Arts	General
1960 Braque illustrates Pierre Reverdy's *La liberté des Mers*	Tapies wins the gravure prize at the International Tokio Biennale	John F. Kennedy elected President of the United States
1961 Chagall carries out 42 colour lithographs to illustrate *"Daphnis et Chloé"*	Pop Art in the U.S.A.: Rauschenberg, Rivers, Lichtenstein, Warhol, Rosenquist and Wesselmann	
1964 *Paravent* 12 colour lithograph by Marc Chagall mounted on board *Prints from the Mourlot Press,* catalogue containing original lithographs by Picasso, Miró, Chagall and Calder	Rauschenberg wins the Venice Biennale prize	
1965 Tapies works on a series of lithographs to illustrate *Novella* a text by Jean Brossa		

GLOSSARY
OF TECHNICAL TERMS

Abrasive. A substance used for grinding and polishing the stone. Usually silicon carbide sand.

Airbrush. A small spray gun for projecting a fine spray of ink or liquid colour by means of a jet of compressed air.

Autography. Process by which a pen and ink drawing is transferred from paper to stone.

Backing. Sheet of compressed fibre-board placed over the paper during printing.

Bed or carriage. Moving part of the press on which the stone is placed.

Bistre. Blackish brown colour, a mixture of lamp black, water and gum.

Blanket. Rubber cylinder which acts as an intermediary between the offset plate and the printing paper.

Chromolithography. Colour lithography.

Dry point. Steel needle set in a wooden handle.

Etch. Solution that fixes the drawing on the stone while protecting non-image areas with a film insoluble in water.

Grain. Slight roughening of the surface of the stone.

Graining. Process of roughening the surface of the stone to enable it to catch the grease in litho crayon.

Graining table. Open-frame table with a tank to catch slurry from graining.

Grinding-stone. Special pumice stone containing a mixture of sealing wax and alum solution. Used for polishing the stone.

Gumming. Spreading gum solution over the stone after preparation to form a thin protective coating.

Half-tones. Tones intermediate between extreme light and extreme shade.

Hand press. Used for lithographic printing. Pressure is applied to the stone by a scraper.

Inking up. Applying ink to the stone with a roller or dabber.

Jigger. Levegator.

Levegator. Round slab of cast-iron with a vertical handle. Used for grinding the stone.

Lever. Lever on hand press lowered to apply pressure.

Lining. Reinforcement of a fragile stone by cementing with plaster to a second stone.

Litho wash drawing. Carried out in diluted litho-ink applied with a brush.

Manière noire. White negative drawing produced by scraping or by using a dry point on a stone previously covered with ink.

Mordant. Substance used in lithography to bite the stone.

Neutralization. Process that removes the protective layer of the preparation, making the stone receptive to greasy particles again.

Oil-stone. Stone used for sharpening scrapers and dry points.

Polishing. Giving a fine grain to the stone.

Registration. Method of making sure that the sheet of paper falls in the right place on each stone during colour printing.

Rollers. Tools for inking up the stone. Wooden rollers covered with leather are used for black and white printing, rubber rollers for colour printing.

Rough. Sketch, often in gouache, used as a reference during colour printing.

Scraper (1). A slab of hard wood, its bottom edge covered with leather.

Scraper (2). Tool with sharp blade used in print making.

Splatter. Method of spraying ink on the stone by rubbing a brush against a small metal sieve.

Tracing paper. Transparent paper used for tracing a design.

Transfer. Way of transferring a drawing directly from paper to stone.

Trial proof. Print made by the artist to help decide the composition's requirements for successful printing.

Washing out. Method of removing litho-ink from the surface of the stone using turpentine.

Water-mark. Transparent mark of design impressed in a sheet of paper to guarantee its quality.

Winch. Part of the hand press turned by the printer to run the stone and paper under the scraper.

Zincography. Printing done with a zinc plate prepared like a lithographic stone.

SELECT BIBLIOGRAPHY

Ouvrages

Aloïs Senefelder, *A Complete Course of Lithography:* "containing good clear directions concerning the different techniques and all their branches and variations, as well as an excellent, full history of this art form from its origins to the present day."
London, 1819
German edition, 1818
French edition, 1819

Godefroy Engelmann, *Traité théorique et pratique de la lithographie.*
Mulhouse, 1840

André Mellerio, *La lithographie en couleurs.*
Paris, 1898

Claude Roger-Marx, *La gravure originale en France de Manet à nos jours.*
Paris, 1938

J. Lieure, *La lithographie artistique et ses diverses techniques.*
Paris, 1939

Jean Bersier, *La lithographie originale en France.*
Paris, 1943

Jean Adhemar, *L'estampe française: la lithographie française au XIX^e siècle.*
Paris, 1944

L. Lang, *La lithographie en France: des origines au début du Romantisme.*
Mulhouse, 1946

A. Calabi, *Saggio sulla litografia.*
Milan, 1958

Felix Brunner, *Handbuch der Druckgrafik.*
Teufen, 1962

Claude Roger-Marx, *La gravure originale au XIX^e siècle.*
Paris, 1962

L. E. Lawson, *Offset Lithography.*
London, 1963

Peter Weaver, *The technique of Lithography.*
London, 1964

S. Jones, *Lithography for artists.*
London, 1967

Wilhelm Weber, *Histoire de la lithographie.*
Paris, 1967
English edition: 1968
German edition: 1961–1964

Michael Knigin and Murray Zimiles, *The tech-*
nique of Fine Art Lithography.
New York, 1970

Michael Twyman, *Lithography 1800–1850.* The
techniques of drawing on stone in England
and France and their applications in works of
topography.
London, 1970

Articles

Le Lithographe, journal des artistes et des impri-
meurs, publiant tous les procédés connus de
la lithographie...
6 Vol.
Paris, 1838–1848

Jean Adhemar, "Les lithographies de paysage
en France à l'époque romantique." *Archives*
de l'art français, vol. XIX, n. s. 1938, pp. 189–
364.

M. L. Twyman, "The Lithography Hand Press,
1796–1850." *Journal of the Printing Historical*
Society, no. 3, 1967, pp. 3–50.

Exhibition catalogues

München. Staatliche Graphische Sammlung.
1961. Bild von Stein, die Entwicklung der
Lithographie von Senefelder bis heute.

Aarau. Kunsthaus, 1971. Hommage à Sene-
felder. Künstlerlithographien aus der Samm-
lung Felix H. Man.

TABLE OF ILLUSTRATIONS

PHOTOGRAPHIC CREDITS

I. Bandy, Paris: 10, 13, 16, 85, front page cover.
Galerie Berggruen, Paris: 27
Bibliothèque Nationale, Paris, Cabinet des Estampes: 31, 92, 93, 95, 100, 105, 112
The Brooklyn Museum, Brooklyn, Department of Prints and Drawings: 79
Galerie Cramer, Geneva: 104
G. Dupuis and J. Guéry, Lausanne: 32, 34, 35, 36, 44, 47, 48, 49, 50, 52, 53, 61, 62, 63, 64, 65, 67, 68, 69, 70, 71, 73, 77, 78, 81, 82, 83
Robert Descharnes, Paris: 74
Jean-Claude Eberhard, Geneva: 14, 15, 18, 24, 30, 40
Claude Gafner, Studio, Geneva: 41
Roger Hauert, Paris: 55
Photo Isiz, Paris: 5, 28, 59
Galerie Maeght, Paris, Photo Claude Gaspari: 29, 57, 97, 101, 109
Claude Mercier, Geneva: 12, 43, 106, 108
Musée d'Art et d'Histoire, Geneva, Cabinet des Estampes: 6, 19, 21, 23, 26, 86, 89, 91, 96, 99, 103
Hans Namuth: 22
Willy Ronis, Paris: 2, 111

The author and publishers wish to express their thanks to those who helped work on the preparation of this book; in particular Pietro Sarto, Edmond Quinche and Denise Voïta of the Atelier de Saint-Prex (formerly Villette), Daniel Divorne and Eugène Schenker at the Centre Genevois de la Gravure Contemporaine, Edwin Engelberts, Geneva, and Francisco Melich, Barcelona.

English version by Julian Snelling and Claude Namy.

Printed in Switzerland